A Light in the Field

Other books by H.M. Scott Smith

The Historic Churches of Prince Edward Island (1986)
The Historic Houses of Prince Edward Island (1990)

A Light in the Field

LIGHTHOUSES, FISHERY BUILDINGS,
BARNS *and* MILLS
of PRINCE EDWARD ISLAND

H.M. Scott Smith

SSP
PUBLICATIONS

© H.M. Scott Smith, 1997.

All rights reserved. No part of this work may be reproduced or used in any form or by any means, electronic or mechanical, including photocopying, recording, or any retrieval system, without the prior written permission of the publisher. Any requests for photocopying of any part of this book should be directed in writing to the Canadian Copyright Licensing Agency.

Published by Goose Lane Editions with the assistance of the Canada Council, the Department of Canadian Heritage, 1997. Reprinted by SSP Publications, 2009.

Edited by Laurel Boone.
Cover: Point Prim lighthouse, Wayne Barrett.
Back cover: Cumberland Cove, Tryon, Wayne Barrett; Barn door, Lionel Stevenson.
Book design by Julie Scriver.
Colour separations by Centennial Print.
Printed in Canada.
10 9 8 7 6 5 4 3

Canadian Cataloguing in Publication Data
 Smith, H.M. Scott, 1944-
 A light in the field.

 Includes bibliographical refrences and index.
 ISBN 0-86492-226-4

1. Architecture, Domestic — Prince Edward Island — History.
2. Historic buildings — Prince Edward Island.
3. Architecture, Domestic — Prince Edward Island — Guidebooks.
4. Historic buildings — Prince Edward Island — Guidebooks.

NA8206.C3S64 1997 710'.9717 C970950107-5

SSP Publications
Box 2472,
Halifax, N.S.
Canada B3J 3E4

Contents

Acknowledgements vii

Foreword ix

Map x

Introduction xiii

Lighthouses 17

Fishery Buildings 33

Barns and Farms 43

Mills 63

Bibliography 73

Index 75

This book is dedicated to

*Irene Rogers (1921-1989)
whose steadfast dedication to the cause
of architectural conservation
provided a model for us all*

*Reshard Gool (1932-1989)
whose enthusiasm helped to
launch this project in 1978*

*Geoff Hogan (1953-1992)
and Marc Gallant (1946-1994)
whose light will always shine brightly over
the path toward responsible conservation.*

Acknowledgements

Much of the research and photography for *A Light in the Field: Lighthouses, Barns, Mills and Fishery Buildings of Prince Edward Island*, *The Historic Houses of Prince Edward Island* (1991), and *The Historic Churches of Prince Edward Island* (1986) was undertaken in the period 1978-1981. I am indebted to Wendy Duff, Faye Pound and Yvonne Pigott and photographer Lionel Stevenson for their extensive field work and dedication to a vast and sometimes elusive cause back in those formative days.

Lionel's photographs deserve special mention. With minimal guidance or suggestion, he has captured the essence of Prince Edward Island architecture within both the cultural and physical landscapes. His photographs are often works of art; stunningly clear and poignant recreations, they are timeless images of the Island's proud building heritage. Photos credited to LS are his.

I would also like to thank Chris Reardon (CR) for his photographic input and Wayne Barrett (WB), Peter Cochrane (PC), Brian Gillis (BG), Dr. Ken MacKinnon (KM), Lawrence McLagan (LM) and Dr. Reg Thomson (RT) for the use of their images. (The credit SS designates my own photos.) I am grateful for permission to reproduce photographs supplied by the Department of Transport, Coast Guard (DOT); Canadian Inventory of Historic Buildings (CIHB); Prince Edward Island National Park (PEINP); and the Public Archives and Records Office of Prince Edward Island (PARO). The nineteenth-century engravings are from *Meachem's Atlas* (MA).

In observing photographers Stevenson, Reardon and McLagan, I have learned much about the photography of buildings and, indirectly, the visual aspects of architecture. They have taught me a different way to "see" buildings objectively, from all aspects, and that motion and haste are not conducive to a deeper appreciation of architecture, the "Queen of the Arts."

I wish to thank Dr. Edward MacDonald, of the Prince Edward Island Museum and Heritage Foundation, for his help in updating various building files and for his editorial assistance, and Bob Hainstock for his editing. The Coast Guard division of Transport Canada has been most helpful with information and drawings of Island lighthouses, and I want to thank the staff of the Provincial Archives of Prince Edward Island for their ongoing assistance.

Thanks to Boston Mills Press and Stoddart for their initial commitment to this series of books and to Goose Lane Editions for repatriating them and publishing this third volume, *A Light in the Field*.

I am grateful for the financial assistance of the Canada Council's Exploration Program, the Department of the Secretary of State, and the Prince Edward Island Council of the Arts, which got this project off the ground so long ago; and for funding from the

Nova Scotia Department of Tourism and Culture, which helped to keep it alive.

 Finally, I wish to express my profound gratitude to the many farmers, fishermen, mill owners and lighthouse keepers on Prince Edward Island who have opened their doors to this inquisitive stranger. Their generosity and co-operation has enabled me to at least partly describe the fabric of this beautiful Island. I apologize for any errors, omissions and misinterpretations.

Foreword

A Light in the Field: Lighthouses, Barns, Mills and Fishery Buildings of Prince Edward Island was born in July of 1978, when I began an investigation into the origins of Prince Edward Island architecture. Documentation of the Island's historic architecture to that point was minimal beyond the Canadian Inventory of Historic Buildings and the efforts of a few individuals. I conducted a superficial survey of all building types in Prince Edward Island, and then I journeyed to southern England and Ireland, the Highlands and Hebrides of Scotland and the New England region of the United States in an attempt to establish the complex correlations between Prince Edward Island buildings and their antecedents. I then selected particular Island buildings for further study, based on certain parameters:

1) in general, those built before 1914;
2) those of a substantial and/or relevant architectural form;
3) those associated with a significant historical event or personality;
4) those in good physical repair and that remain as faithful as possible to their original state.

The intent of my research has been to produce four distinct catalogues of architecturally and historically significant pre-First World War buildings in Prince Edward Island, with brief insights into their origins. This third book, *A Light in the Field*, follows *The Historic Churches of Prince Edward Island* (1986) and *The Historic Houses of Prince Edward Island* (1991). The final book in this series will focus on public, institutional and commercial buildings.

I would ask that visitors and admirers respect the properties featured in this book and the privacy of their owners. Unless it is a public site, do not trespass, disturb the inhabitants or remove souvenirs. Viewing should be from public roads, and due courtesy should be shown in taking photographs or videos. Lighthouses, fishing wharves and mill sites can be dangerous to visitors on foot, so caution should be taken in visiting them.

This book is not intended as a history text or a manual of preservation, yet I hope that it and its predecessors will prove useful tools in the conservation effort. I conceived this project and these books as a beginning, in the hope that architectural historians, geographers, academics and other interested individuals might be inspired to do further research and to document the various aspects of architectural, social and community history touched on only briefly within the scope of these books. To this end, I have adopted a subjective but uncritical stance, wishing to make this information accessible and enjoyable to everyone.

SCOTT SMITH
Halifax, April, 1997

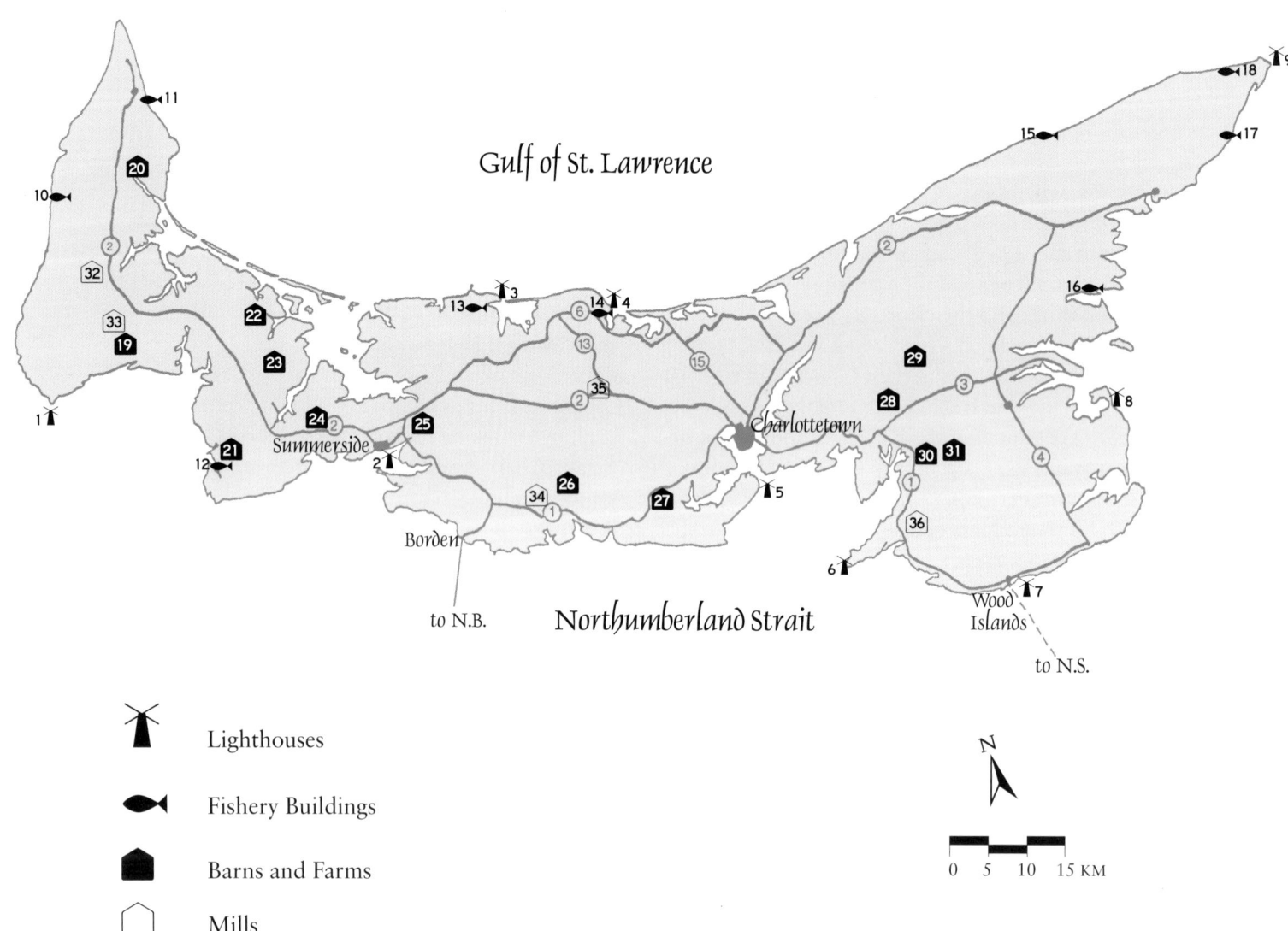

A Light in the Field

x

Lighthouses

1. WEST POINT
2. INDIAN HEAD
3. NEW LONDON
4. NORTH RUSTICO
5. ROCKY POINT (BLOCKHOUSE)
6. POINT PRIM
7. WOOD ISLANDS
8. PANMURE ISLAND
9. EAST POINT

Fishery Buildings

10. MIMINEGASH
11. TIGNISH RUN
12. ACADIAN CO-OP, ABRAMS VILLAGE
13. FRENCH RIVER
14. COURT BROTHERS, NORTH RUSTICO
15. NAUFRAGE
16. ANNANDALE
17. BASIN HEAD MUSEUM
18. NORTH LAKE

Barns and Farms

19. ROGERS FARM, BRAE
20. RAMSAY FARM, MONTROSE
21. GALLANT BARNS, ABRAMS VILLAGE
22. RICHARDS CARRIAGE HOUSE, BIDEFORD
23. MILLIGAN FARM, NORTHAM
24. GILLIS BARNS, MISCOUCHE
25. POTATO BARN, WILMOT VALLEY
26. MOORE BARNS, WESTMORELAND
27. STRATHGARTNEY, BONSHAW
28. HAY BARRACKS, LAKE VERDE
29. CORCORAN BARN, BALDWIN ROAD
30. ORWELL CORNER
31. GILLIS BARNS, LYNDALE

Mills

32. MACAUSLAND'S MILL, BLOOMFIELD
33. LEARD MILL, COLEMAN
34. IVES MILL, NORTH TRYON
35. BAGNALL'S MILL, HUNTER RIVER
36. PINETTE MILL, BELFAST

A Light in the Field

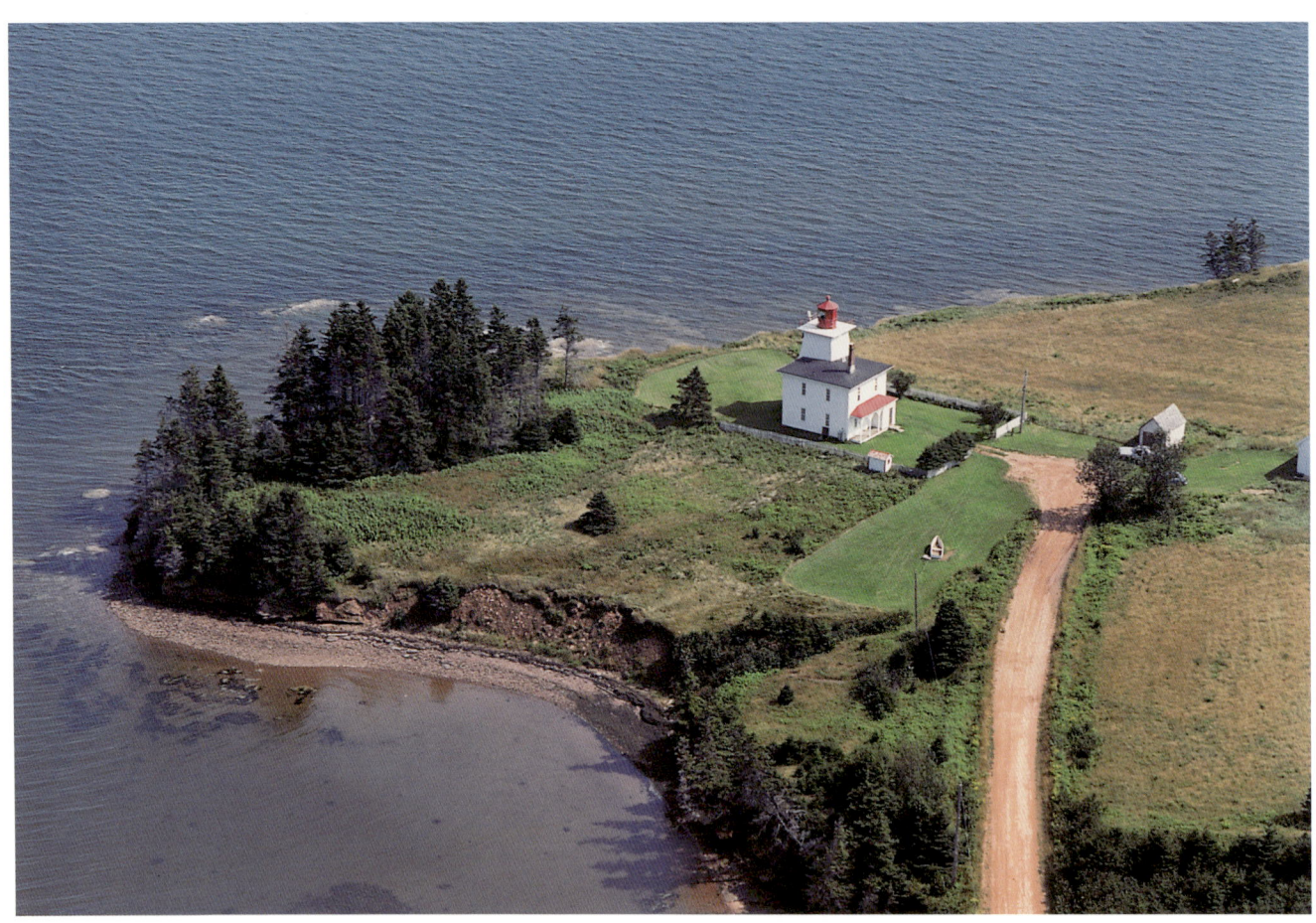

BLOCKHOUSE, ROCKY POINT. (LS)

A Light in the Field
xii

Introduction

The Mi'kmaq and the early European settlers on Prince Edward Island had to farm and fish in order to survive. Eventually, they built lighthouses to guide their way home from the sea and mills to process the harvests of farm and forest. Today, the Island is an agricultural utopia — The Garden of the Gulf, as it is called. Its lush, fertile fields, pristine farmsteads and huge processing plants represent an industry that is flourishing, with markets world-wide. Family farms, while diminishing in numbers, have succeeded from generation to generation; the progress of science and modernization in the processing of agricultural and fish products have perfectly complemented the resourcefulness, tenacity and skill of the Island farmer and fisherman. The fishery, while threatened with a regional diminishing of stocks, became a vital component of the Island economy in the early 1870s. Along with a healthy tourist trade, these two industries form the economic heartbeat of the Island, and their buildings represent its very soul.

The hardy and resourceful Scots, Irish, English and Acadians carved communities out of the wilderness on Prince Edward Island because they had a will to do so, resolutely adhering to the principles of useful and functional architecture from one generation to the next. There is no doubt that a practical pride in good workmanship and resourceful stewardship has maintained this building stock, for Islanders are extremely aware of their architectural heritage.

Prince Edward Island architecture is unique because of the forethought and practicality of these pioneer builders, who placed decoration in a symbolic role in the context of an economic style. Lines are clean and straight, with precious little wasted space and few superfluous elements. The rolling topography and the extreme coastal climate, with heavy precipitation and high winds, have made it necessary for Island builders to look for shelter — the lee side of a hill, a protected harbour or a windbreak of trees. The idyllic postcard scene of a pastoral Island farm often does not reveal the strategy behind the situation and form of the structures on it. The location of the main barn, for example, was critical, relative to the function of the other farm buildings.

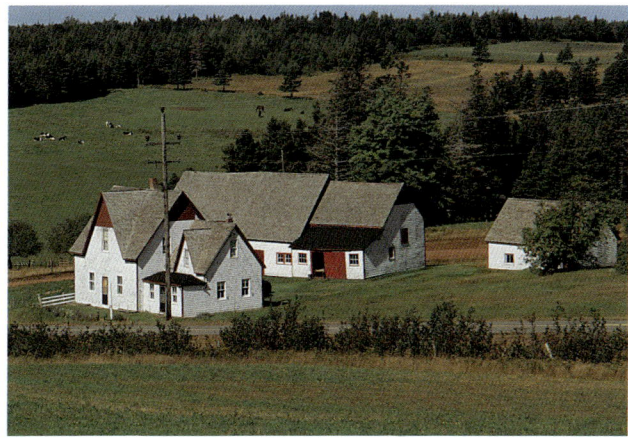

MacLeod Farm, Hartsville (SS)

A Light in the Field

xiii

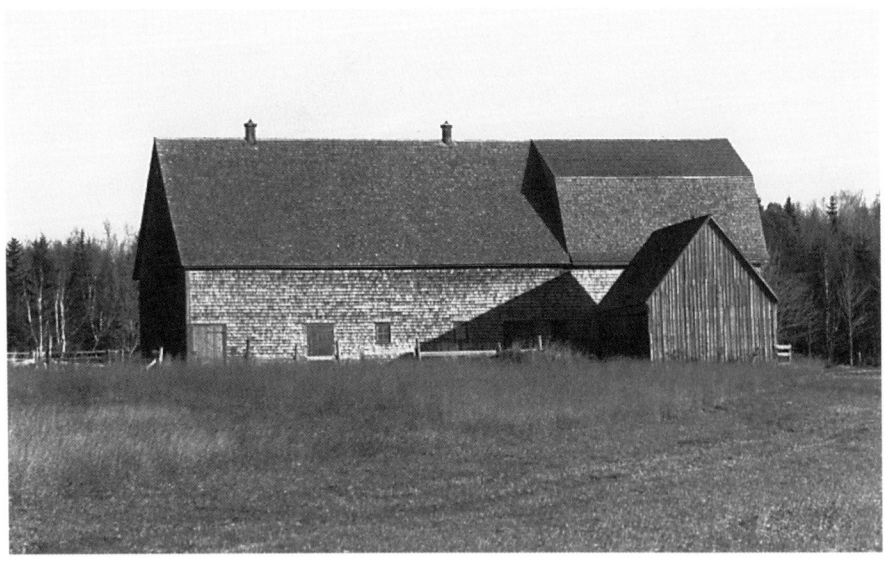
BARN AT DESABLE. (LS)

A mill was usually situated on a river or stream, the early source of its power and, in the case of lumber mills, the conduit of its raw materials. The correct location of a lighthouse was crucially important. Fishing communities and processing plants grew around sheltered harbours.

The architecture of this culture forms the fabric of a vibrant coat of many colours — a cloak worn with a quiet, confident dignity by the dedicated and hardworking farmers and fishermen of Prince Edward Island. At first glance, the lighthouses, fishing shacks, barns and mills of the nineteenth and early twentieth centuries may appear to be simple, utilitarian buildings but a closer examination reveals not only a sophisticated functionality but a glimpse into the Island character. Every aspect of this architecture has a purpose, from the elegant simplicity of the Panmure Island lighthouse (see page 29) to the stylish functionalism of a barn in Desable. It is quite commonplace on Prince Edward Island to find lobster traps stacked in a farmer's barnyard because the seasonality of particular crops such as corn, strawberries or tobacco would sometimes allow the enterprising farmer to also fish lobster or harvest Irish moss. Often, the farm buildings might reflect this unique approach to mixed farming.

Prosperity is a well-known enemy of architectural conservation because it promotes new construction. Today, in a period of relative prosperity in Prince

NEAR GRAND TRACADIE. (PC)

A Light in the Field
xiv

Edward Island, the stock of historic buildings is gradually dwindling. It is always a shock to discover that a barn, mill or lighthouse has disappeared. Fireproofing safeguards and building code protection are not as stringent for these buildings as for domestic buildings, and some barns and mills simply outlive their usefulness in the face of unrelenting modernization and diversification. This is particularly true of lighthouses, which are now fully automated. The abandoned Ives grist mill in North Tryon (see page 68) and the magnificent main barn on the Rogers' farm in Brae (see page 55), destroyed by fire in 1992, are poignant reminders of the forces of attrition. Although Prince Edward Island is quite advanced in the area of conservation awareness (in fact, it proclaimed the Heritage Places Protection Act in 1995), it is important that all responsible governmental heritage organizations and agencies adopt and maintain policies of inventory and education rather than merely relying on legislation in order to preserve the integrity and promote sympathetic re-use of those buildings threatened with obsolescence, destruction or decay.

Architecture is an art form that is meant to be contemplated as well as to be used. Visually, the unity of lines, colours and elements is remarkable on Prince Edward Island, and, nestled in the lush, rolling hills of the Island countryside or marking its headlands, these buildings suggest a harmony that makes one feel as if they were always meant to be there.

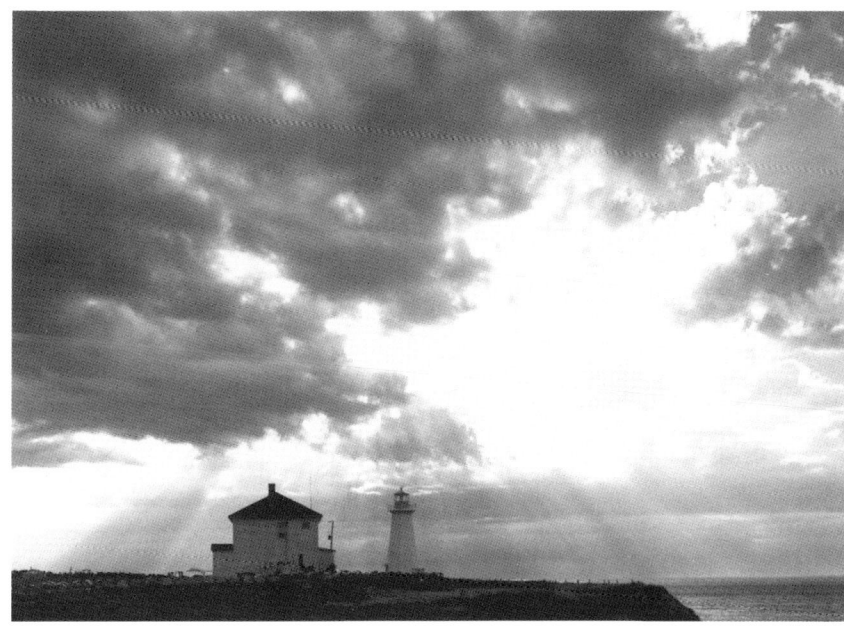

NAUFRAGE LIGHTHOUSE. (LM)

A Light in the Field

xv

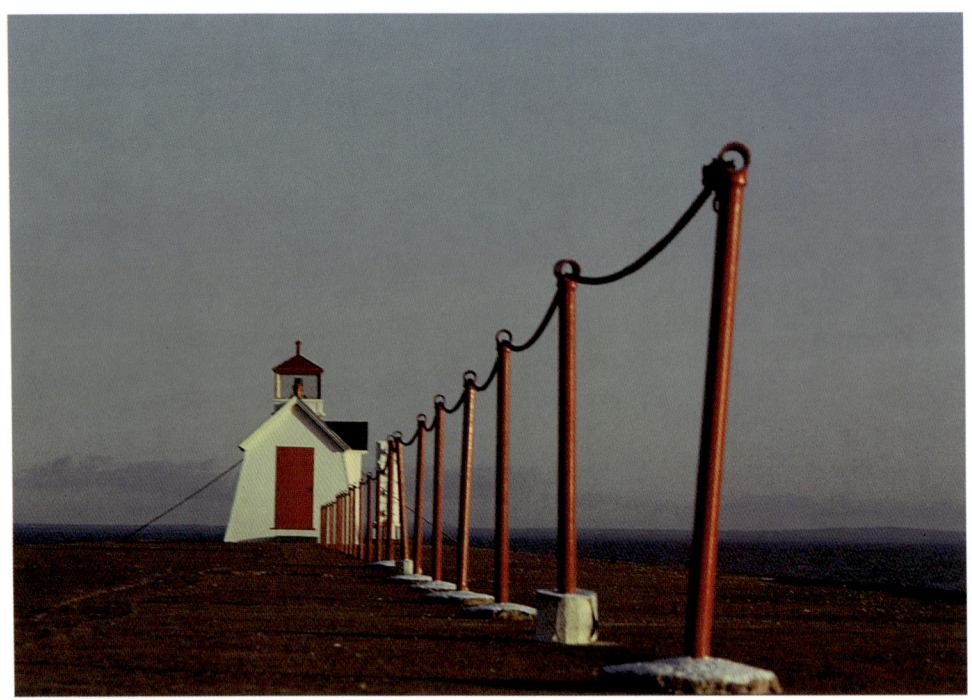

Wood Islands jetty light. (CR)

A Light in the Field

Lighthouses

The lighthouse in Atlantic Canada is the most essential and fabled of all coastal structures. Many a ship has been lost because of a badly situated or non-functioning lighthouse or the absence altogether of a warning beacon. Erosion of coastal terrain has necessitated the raising, reinforcement or complete relocation of some Maritime light stations, including several on Prince Edward Island, most notably the lighthouse at East Point (see page 30).

Lighthouses on the Island were usually located on the most strategic land protuberances, built initially to protect the shipping lanes, and fall into two basic architectural categories. One is the free-standing tower, either square, circular or polygonal — usually octagonal, although square towers became the norm after the Island joined Confederation in 1873. The other is a tower attached to a dwelling unit, usually a simple, gable-roofed structure, one storey in height, such as the lighthouse at Wood Islands (see page 28). An exception is the lighthouse at Indian Head (see page 26), an octagonal tower built directly atop a larger octagonal dwelling at the end of a long breakwater guarding Summerside Harbour.

Lighthouses on Prince Edward Island, and in Atlantic Canada in general, were built almost exclusively of timber frame construction because of the abundance of wood. A notable exception is the oldest and tallest lighthouse on the Island, the one at Point Prim; beneath a shingle veneer, it is built solidly of brick, and dates back to 1845-46. The smaller range lights and harbour lights were built as utilitarian skeletons of iron, steel or wood.

INTERIOR, EAST POINT LIGHTHOUSE. (LS)

Lighthouses often show a great deal of sophistication in the manner in which framing members and joist systems taper and diminish with increasing height. Concessions to the tapering walls were often made quite skilfully and were sometimes playfully expressed in angular door frames and twisted stair balusters. Expert carpenters, drawing on military or shipbuilding experience, would sometimes use ship's knees to reinforce the frame. The wooden superstructures were very sturdy, built of oversized timber to support the considerable weight of the lanterns, gear assemblies and driveshafts. The light platforms themselves were often prefabricated iron assemblies that, along with the other machinery, could outlive the wooden superstructures. Many early lighthouses were built on foundations of local sandstone, but because of settling or disintegration, these bases had to be replaced with

Lighthouses

walls of poured concrete or concrete block. Decorative features were minimal and usually restricted to door and window trim and vibrant colour schemes.

The attached living quarters were Spartan, with lath-and-plaster inner partitions. The outer walls were often shingled, but when the severe coastal climate took its toll, the shingles had to be replaced with more durable clapboard or shiplap. Because of the moist, salty air and the long Prince Edward Island winters, these frame structures, many of them unheated, have required constant maintenance. Recently, the Canadian Coast Guard has elected to protect many of their active light stations with chain link fences. However, many inactive lighthouses are accessible to the public as craft shops and museums.

Lighthouse development in North America has no technical history to compare with that in Britain and Europe, but the progressive improvement of lighting equipment and optical apparatus has had universal impact. The earliest light warning devices were open fires, strategically located, but in due course these were replaced by lamps fuelled by whale oil or cod liver oil. In many cases a crude arrangement of mirrors reflected the light seaward.

In 1782 a Swiss named Argand invented a more efficient burner; by the 1820s it was used extensively in Britain. The next refinement was parabolic reflectors, developed in the 1830s. Designed on the catoptric principle, these reflectors increased the power of an Argand lamp seven-fold, and were used widely in Canada until the late nineteenth century. In 1823 a Frenchman named Fresnel developed a dioptric lighting apparatus that, with the refraction of light through a system of lenses and prisms, increased the power of the light source dramatically. By mid-nineteenth century in Britain, both systems had been combined into what was known as a catadioptric system, later simply called dioptric.

FRESNEL LENS. (*THE LIGHTHOUSE*)

Until the 1850s the Argand lamps burned whale oil, but by 1864 they were being converted to coal oil or kerosene for economic as well as technical reasons. By 1904 petroleum vapour lamps were reportedly increasing candlepower by 345 percent, and in the early 1900s many lights were converted into acetylene gas lamps. In the 1930s, electricity became not only the power source for the rotational machinery, which formerly had employed pulleys, shafts and weights to turn the lamps, but the light source as well — in the form of the incandescent filament lamp. Electrification came to Prince Edward Island lighthouses only in the 1950s, concurrently with the post-war conversion to mercury vapour lamps.

Although most lighthouses have become fully automated as a result of the parallel development of radar and radio communications, the diaphone fog alarm and computerized electronic remote control

A Light in the Field

systems, many Island light stations have, at one time or another, been manned. In some cases, the lighthouse keeper lived in an attached dwelling, as at Wood Islands or Rocky Point. Other lighthouses, such as the one at East Point, had a small detached dwelling nearby. The Island lighthouses most recently manned were those at Wood Islands, Panmure Head, Souris and East Point, but all are now fully automated.

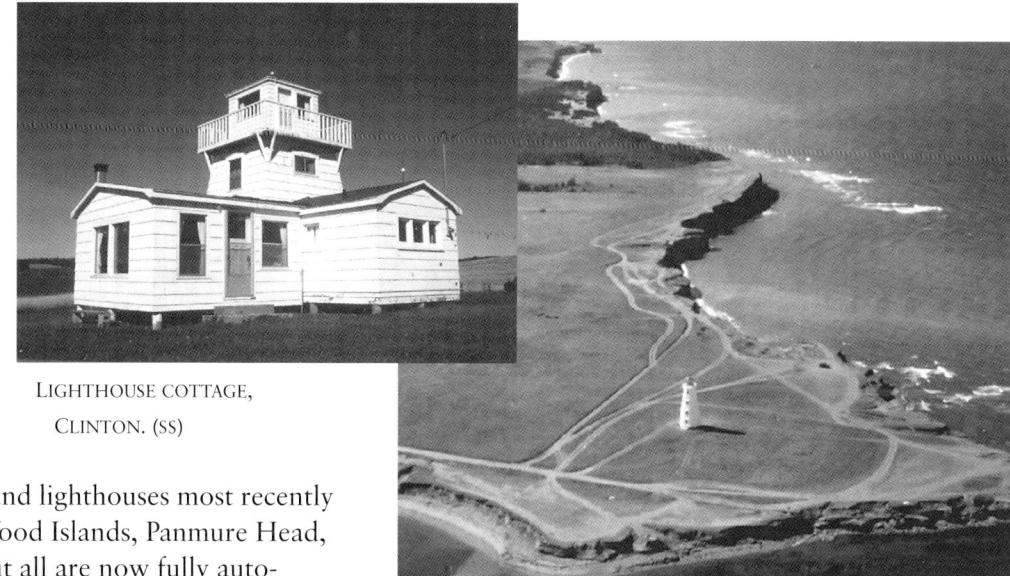

LIGHTHOUSE COTTAGE, CLINTON. (SS)

NORTH CAPE. (WB)

Today the lighthouses on Prince Edward Island are serviced by road, helicopter or supply ships of the federal Ministry of Transport, Coast Guard division. Thus lighthouse keepers are now maintenance technicians. The romance and drama that surrounded these diligent and hearty men is over. Lightkeepers often risked their lives to keep a light burning in a storm, and because of the isolation inherent in the job, only a special kind of personality could survive. The lightkeeper was essential to navigation, particularly during Prince Edward Island's shipping and ship-building boom in the mid-nineteenth century. Though the lighthouse keeper has perhaps disappeared forever, his riveting accounts of storm and shipwreck, rescue, phantom ships, ghosts and buried treasure will surely live on as a vital part of our nautical folklore. From the windswept North Cape to East Point, each solitary lighthouse has its own tale to tell.

With the dramatic advancement in optical technology and increased range, some lighthouses have become redundant and have been removed altogether. Some have found interesting new uses, such as one used as a summer cottage at Clinton. The lighthouse in any form is still a welcome sight to ship's navigators and an integral part of the Island's coastal architecture.

Lighthouses

Point Prim Lighthouse

The oldest lighthouse on Prince Edward Island, built in 1845-46, stands on a point of land at the southern end of Hillsborough Bay on the outer approach to Charlottetown Harbour. The Point Prim light, one of the tallest on the Island at 60 feet (18.3 metres), is a tapered, circular brick tower that commands a beautiful view of up to 30 nautical miles over the Northumberland Strait.

The Point Prim lighthouse (also see front cover) stands on a nine-acre (3.6-hectare) site donated by the Lord Selkirk. In 1845 the Prince Edward Island House of Assembly approved a grant of money for its erection. In April of that year, a House-appointed committee, including a surveyor, land agents and the high sheriff proceeded across the ice from Charlottetown in ten sleighs to Point Prim, 16 miles (25.5 kilometres) away. On arrival, they selected and surveyed the site for the new lighthouse and made arrangements for local contractors to clear the land. After a brief lunch, the party returned across the ice to Charlottetown in one hour and twenty minutes. The lighthouse was designed by architect Isaac Smith and built by Charlottetown contractor Richard Walsh; the interior gear machinery was designed and built by Thomas Robinson. The first lighthouse keeper was William Finlayson, hired at a salary of £50 a year. In 1846 an even larger party of some twenty sleighs crossed the ice from Char-lottetown, "with the British colours gaily flying," to inspect and marvel at the completed building.

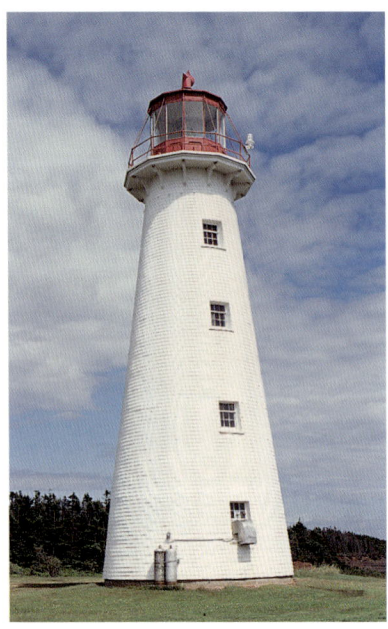

POINT PRIM LIGHTHOUSE. (LS)

The lighthouse was extensively renovated in 1884 but retains a central weight shaft that was part of the original mechanical light rotation device. The structure remains in its original condition, except for a veneer of shingles applied at the turn of the century. The present fully automated mercury vapour light source, with an effective range of 20 nautical miles, is the last of its kind to be installed on Prince Edward Island. In 1975 a wooden frame lighthouse keeper's cottage immediately adjacent was judged to be surplus property, and in the summer of 1976 it was sold and removed. Because of Point Prim's well preserved history and the stunning view from the site, the lighthouse attracts many summer visitors. For this reason a nearby building was renovated in 1992 to provide more amenities.

A Light in the Field

Blockhouse, Rocky Point

The lighthouse at Rocky Point, or Blockhouse as it is historically known, is unique and one of the most charming of all Island lighthouses. Located near Fort Amherst-Port La Joye National Historic Park, at the west side of the entrance to Charlottetown Harbour, it has guided vessels of all kinds into the sanctuary of the port since the first light was established in 1849. The light was originally a kerosene lamp, later changed to a gas lantern (see also page xii).

James Butcher built the present lighthouse and attached dwelling in 1876-77 at a cost of $2750. The strategic location of this lighthouse gave it a stature that is reflected not only in the size of the building but in its architectural detail. The pedimental window heads, flared eaves, shingle cladding and corner boards give it a character that most other lighthouses lack. The integration of the 40-foot (12-metre) tower and the dwelling is outstanding, and the structural demands of this union are a tribute to the carpentry skills of the builder.

The light was originally a kerosene lamp, later changed to a gas lantern. In 1962 an electric mercury vapour light, with an increased range of 18 nautical miles, was installed. The lighthouse keeper's role has subsequently been reduced to that of caretaker and groundskeeper. That role is presently filled by Merrill Taylor, who leases the dwelling, tends the property and guides curious visitors during the summer. His father, Stanley Taylor, was the lighthouse keeper from 1935 to 1962.

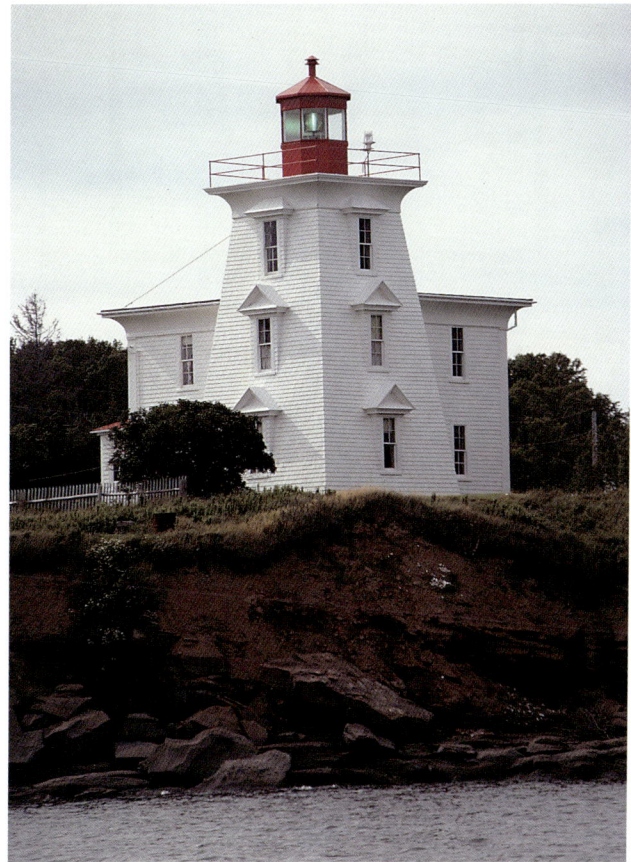

BLOCKHOUSE LIGHTHOUSE, ROCKY POINT. (LS)

Lighthouses

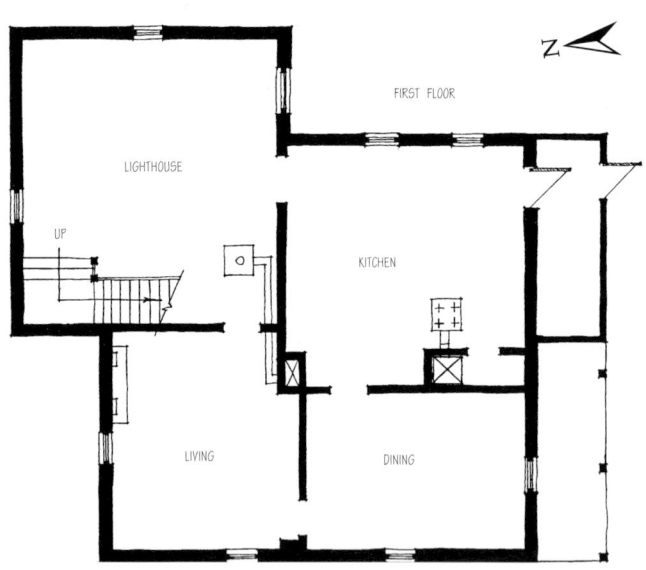
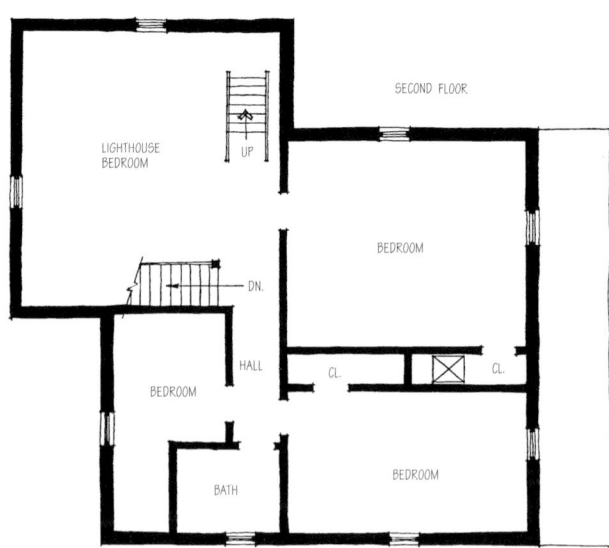

FLOOR PLANS. (NOT TO SCALE) (SS)

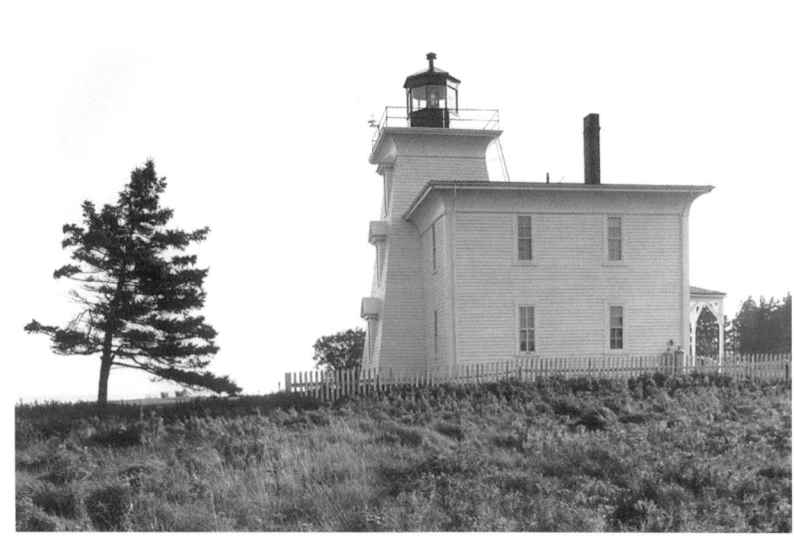

BLOCKHOUSE LIGHTHOUSE, ROCKY POINT. (LS)

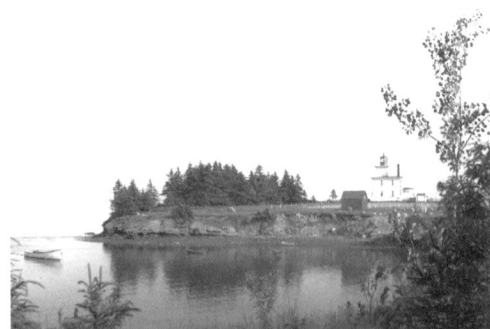

BLOCKHOUSE LIGHTHOUSE, ROCKY POINT. (LM)

A Light in the Field

West Point Lighthouse

Now a major tourist attraction on a beautiful wind-swept bluff overlooking the western entrance to the Northumberland Strait, the West Point lighthouse was completed in 1876. At 85 feet (26 metres), the square tower is one of the tallest and most striking on the Island. Its broad black horizontal bands were originally red, but in 1915 they were repainted to provide more contrast against the dazzling sunsets. The attached dwelling is an accurate reconstruction, but it now houses nine guest rooms and a restaurant. For fifty years William MacDonald tended the light from the original dwelling. His successor, Bennie MacIsaac, occupied the house until 1963, when the light was converted to a fully automated, revolving electric light. Shortly after, the dwelling was removed, but in the mid-1980s it was rebuilt to the original plans.

Construction of the tower began in 1875, under the supervision of William MacDonald, who walked all the way from West Point to North Cape to study the lighthouse there. Suitable building materials could not be found locally, so stone and timber were brought to West Point by sailboat from New Brunswick. The tower tapers from 29 feet (8.8 metres) square at the base to 12 feet (3.7 metres) square at the platform. Bracketing under the lantern platform, tall windows with pedimental hoods, and a reconstructed balustrade around the bright red housing of the lantern are the significant architectural elements

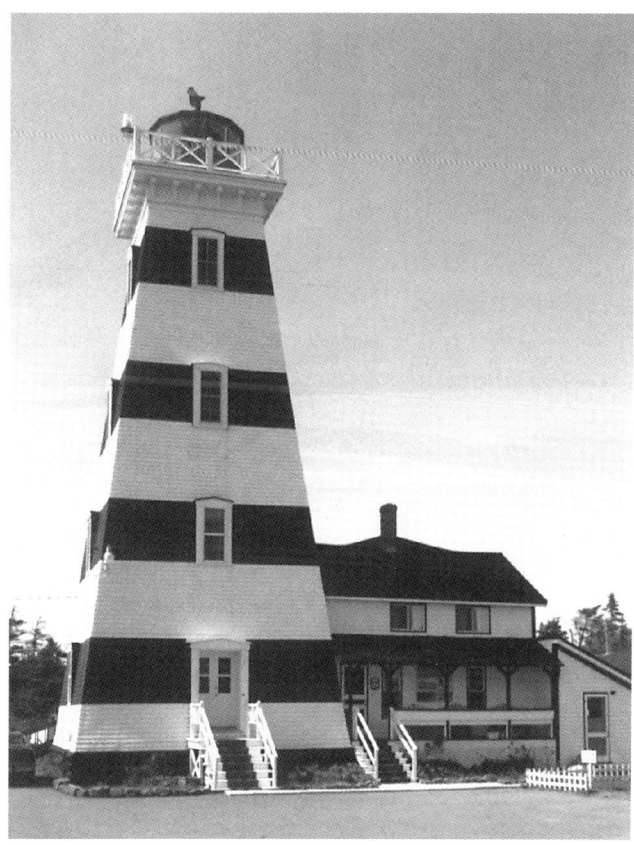

WEST POINT LIGHTHOUSE. (SS)

that have survived. Visitors to the lighthouse today will find interpretive displays and evidence of the original pulleys, shafts and gears that were used to rotate the lantern. An adjacent craft shop and a provincial park nearby help to make the lighthouse an interesting and fulfilling destination.

Lighthouses

New London Lighthouse

The rear range light on New London Bay, east of French River, was built in 1876 and is another good example of a lighthouse with attached living quarters. During a severe gale in 1879, the lighthouse was lifted off its foundation and transplanted 650 feet (198 metres) westward, to its present location. In 1944 extensive renovations were carried out, including the installation of a concrete foundation. The flashing electric light still functions as a crucial navigational aid, but since 1968, the dwelling has been leased as a summer cottage from the Department of Transport. Beautifully situated on a beach overlooking New London Bay, this well-maintained lighthouse has a pleasing angularity.

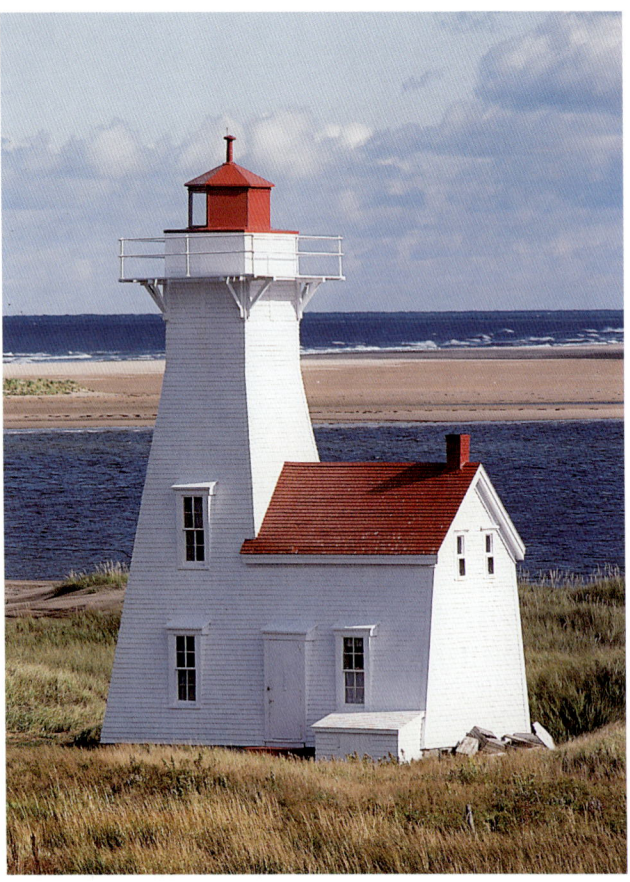

NEW LONDON LIGHTHOUSE. (LS)

A Light in the Field

North Rustico Lighthouse

The lighthouse at the entrance to North Rustico harbour on Prince Edward Island's famous North Shore is one of several remaining lighthouses with a dwelling attached. The first North Rustico light was established in 1876, but the present lighthouse was not built until 1899. This wooden lighthouse was raised four feet (1.2 metres) in 1978 to increase the range of the light and to install a concrete foundation. The tower is 29 feet (8.8 metres) high to the platform, 37 feet 6 inches (11.4 metres) to the vane, 15 feet 6 inches (4.7 metres) square at the base and 7 feet 3 inches (2.2 metres) square at the top. The attached three-room dwelling was periodically occupied by various lightkeepers until 1960, when the light was converted to a totally automated electric system. Despite the fact that the lighthouse has had only one major renovation, in 1921, it is still in excellent condition. Although its future was somewhat in doubt in the 1970s, the light was re-established in 1976. The attached cottage now houses the electronic controls and site maintenance equipment.

The most notable lighthouse keeper at North Rustico was George ("Joe Polly") Pineau, who began tending the kerosene lamps in 1917. He continued as lighthouse keeper for 35 years, even after the light was electrified in the early 1950s. After his retirement at age 70, Mr. Pineau promptly resumed his life as a fisherman.

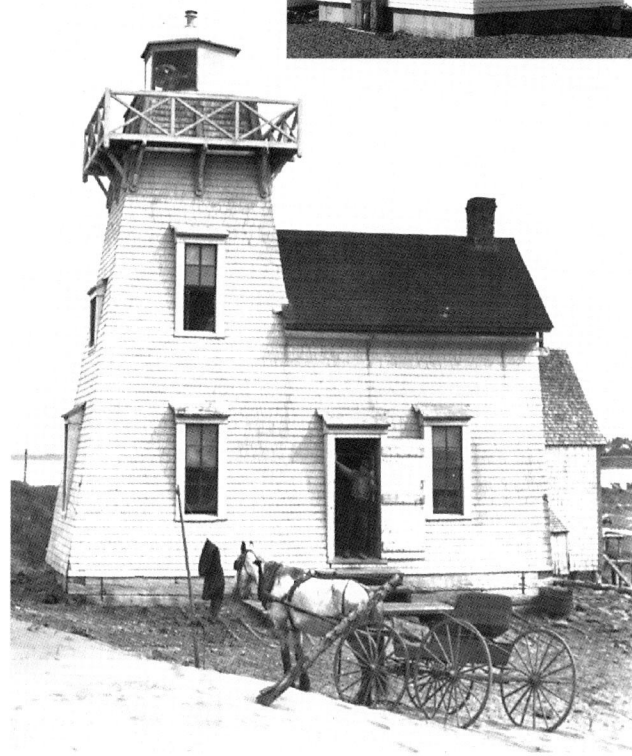

Right: NORTH RUSTICO LIGHTHOUSE. (LS)
Below: NORTH RUSTICO LIGHTHOUSE, CIRCA 1930. (DOT)

Lighthouses

Indian Head Lighthouse, Summerside

The lighthouse at the south entrance to Summerside harbour is unique on Prince Edward Island. It is located at the end of a mile-long breakwater off MacCallums Point (historically known also as Indian Point). At high tide, this lighthouse cannot safely be reached by foot.

The lighthouse consists of an octagonal light tower, 40 feet (12 metres) tall, that is mounted atop a larger octagonal building that was intended to serve as a lighthouse keeper's dwelling; no one has actually lived in this building. The light tower was built in 1881 by a contractor named Keefe. The first keeper of this light was Captain Charles Peters, who came to Summerside as a sea captain in 1855. It is now a fully automated system, and service technicians visit by boat as required. The flashing light has a range of 11 nautical miles.

Indian Head lighthouse is a model of good functional and proportionate design. Each side of the octagonal tower is 5 feet (1.5 metres) wide. The inside diameter is 10 feet (3 metres). The octagonal dwelling below it is 12 feet (3.7 metres) on each side and has an inside diameter of 26 feet 6 inches (8.1 metres). The superstructure is mounted on a solid circular foundation of reinforced concrete and stone below the low-water line. There were plans for an adjoining boathouse, but it was never built.

The breakwater was built in 1885 on a sand bar projecting into the harbour. Severe ice conditions

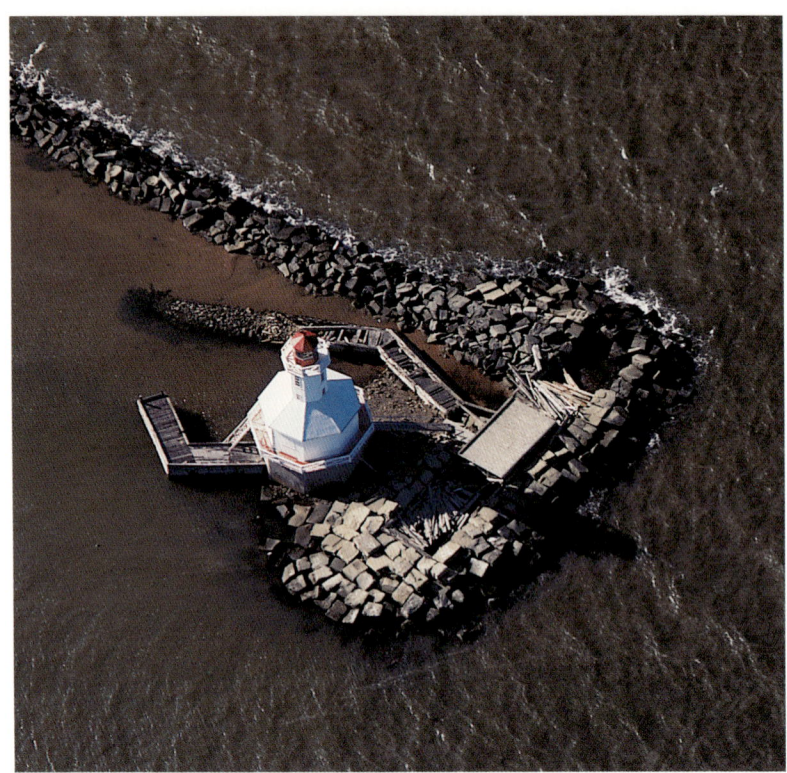

INDIAN HEAD LIGHTHOUSE, SUMMERSIDE. (LS)

A Light in the Field

during the winter months have taken their toll on cribwork and boat docks around the lighthouse. Major repairs and dredging were carried out in 1932 and 1952.

From the water, Indian Head lighthouse has a distinct profile, standing proud and vigilant. Railings at both the dwelling and light room levels, shingle cladding and surrounding rubble stone contribute to this strong visual character.

INDIAN HEAD LIGHTHOUSE JETTY, SUMMERSIDE. (SS)

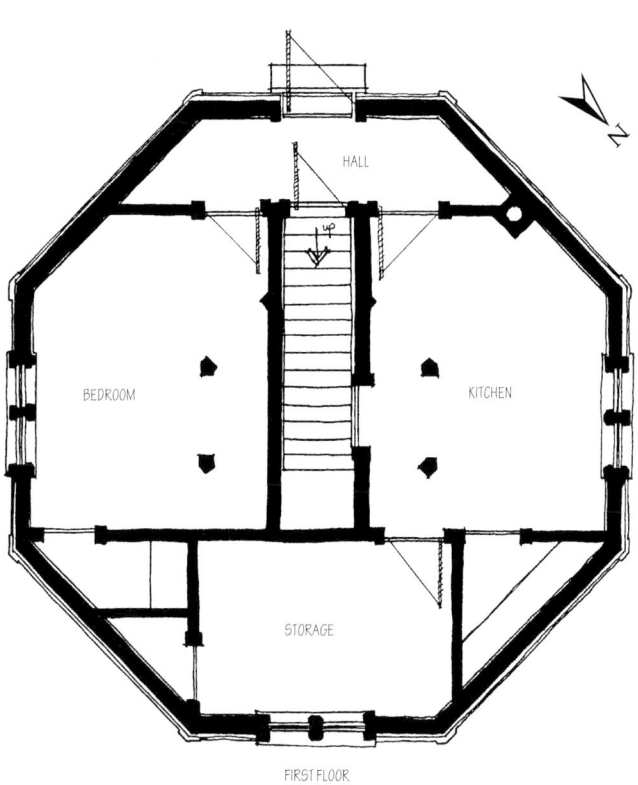

FLOOR PLANS, INDIAN HEAD LIGHTHOUSE, SUMMERSIDE. (NOT TO SCALE) (SS)

Lighthouses
27

Wood Islands Lighthouse

The lighthouse at Wood Islands is a familiar sight to those travelling via ferryboat between Wood Islands, Prince Edward Island, and Caribou, Nova Scotia, as it is situated only a few hundred metres east of the main entry to Wood Islands Harbour. The square light tower, 50 feet (15.2 metres) tall, is attached on its northwest corner to a simple, gabled dwelling.

Since Department of Transport records began in 1910, there have been many repairs and minor renovations to the lighthouse. A major renovation took place in 1950, when the house was completely refurbished and a kitchen addition built at the rear to accommodate the needs of the full-time lightkeeper, George Stewart, and his family. A new concrete foundation was poured, the roof of the dwelling was reshingled, and wooden gutters and downspouts were installed. A new well was drilled about 100 yards (91 metres) to the northeast to provide a reliable water supply, not only for the lighthouse but for local fishermen as well.

In 1941 a hand-operated fog horn was installed at the harbour mouth to assist the ferry in docking. The automation of this device in 1979 eliminated the need for an assistant lightkeeper. The lighthouse itself was electrified in 1958, and the equal-interval mercury vapour lamp has a range of 12 nautical miles. Wood Islands was one of the last Island lighthouses to be fully automated; it had been manned continually from its construction in 1876 until 1989.

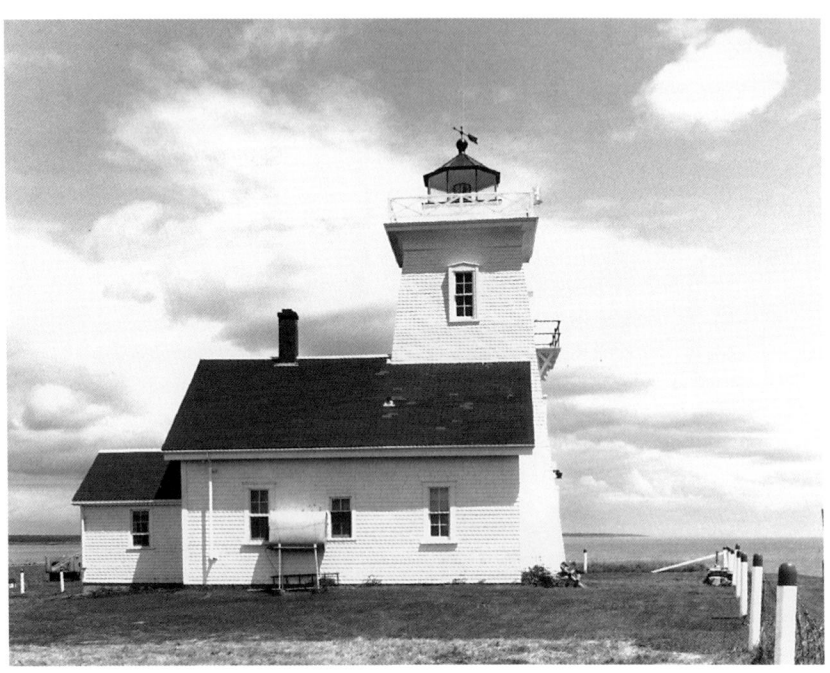

WOOD ISLANDS LIGHTHOUSE. (LS)

A Light in the Field

Panmure Head Lighthouse

The lighthouse on Panmure Island is an octagonal, free-standing tower 58 feet (17.7 metres) tall. It was built in 1853, on the recommendation of surveyor Captain Bayfield, who thought its location critical for warning ships of the formidable Bear Reef and others on Panmure Ledge. According to Department of Transport records, the lighthouse underwent major renovations in 1861, 1875 and 1956. These renovations included reshingling the building and replacing the original sandstone foundation with one of poured concrete. Hydroelectric power came to Panmure Island in 1958, and the mercury vapour light, with a range of 20 nautical miles, became fully automated in 1961.

A simple gabled building that housed the electric fog alarm system, installed in 1971, used to stand close by, but it has been relocated to an adjacent property. Its former floor slab is now used as a helicopter landing pad. The lightkeeper's dwelling, built in 1958, is located just to the northwest, on the light station road. It and the fog alarm building are now privately owned.

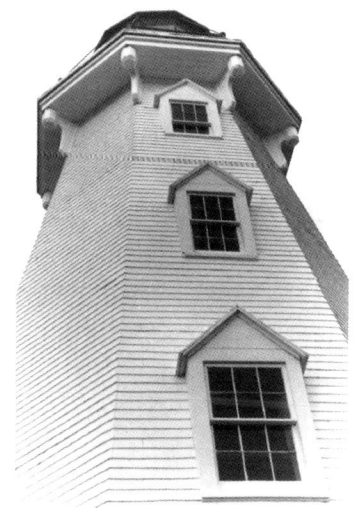
PANMURE HEAD LIGHTHOUSE. (SS)

The Panmure Head lighthouse is a building of wonderful scale and considerable charm. Its shingled siding, hand-hewn beams, six-over-six window sashes with gabled hoods, and the sculpted brackets that support the lantern platform give the building a distinctive character that does not go unnoticed by the many visitors to the beach of a nearby provincial park.

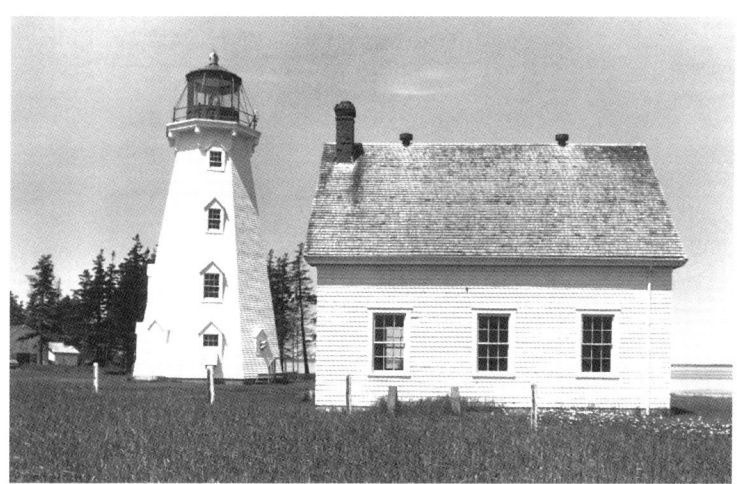
PANMURE HEAD LIGHTHOUSE AND FOG ALARM BUILDING. (LS)

Lighthouses

East Point Lighthouse

On a point of land at the extreme eastern tip of Prince Edward Island that the Mi'kmaq called Kespemenagek (the end of an island) stands East Point lighthouse, overlooking the confluence of three tides: from the Atlantic Ocean, the Northumberland Strait and the Gulf of St. Lawrence. One of the most fabled and strategically located of the Island's lighthouses, it was built in 1867 by a local contractor named William MacDonald, initially on a higher piece of land half a mile (800 metres) inland from its present location. Many ships foundered off this point, but the grounding of the British warship *Phoenix* in 1882 was blamed partly on the fact that the light was so far removed from the point. Consequently, in 1885, the lighthouse was moved out to the point by Bernard Creamer of Souris. This was the first major contract undertaken by this prolific and well-known builder. At the same time, a fog alarm was installed in a building next to the lighthouse. In 1908 erosion of the seaside cliffs nearby necessitated a second move of the lighthouse 200 feet (61 metres) inland to its present location. A new fog alarm building was constructed on the site where the light formerly stood, and the old fog alarm shed was moved back for use as storage. In 1917 the steam-powered fog alarm equipment was replaced by a compressed air system, and in 1935 a radio beacon was installed. In 1965 an F-type diaphone fog alarm was installed, followed by an electric foghorn in 1971. Local residents claimed that the original steam equipment was the best, and that the signal could be heard in Souris, 16 miles (25.7 kilometres) away.

The first lighthouse keeper was Alexander Beaton, the owner of the farm on which the lighthouse stands. There have been four other lightkeepers, but the man with the longest service was W.S. MacIntyre, who served from 1926

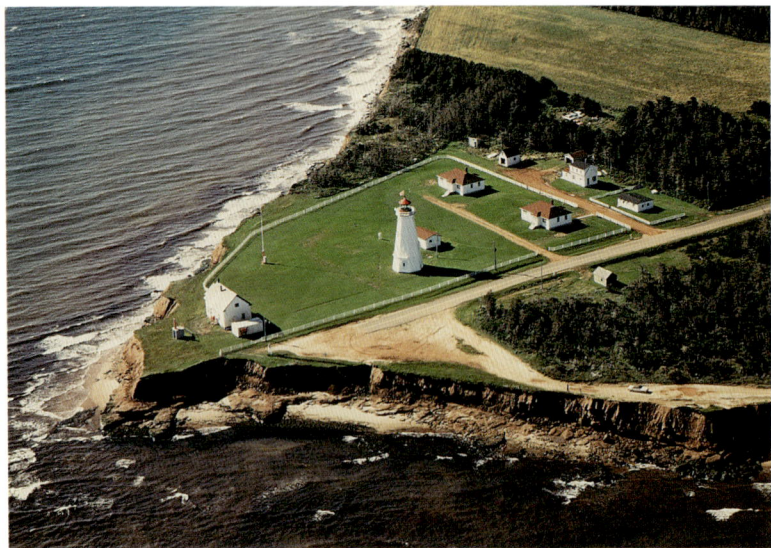

EAST POINT LIGHTHOUSE. (LS)

A Light in the Field

30

to 1962. As many as thirteen ships foundered on the East Point reef during his term. He did much of the landscaping that enhances this popular tourist attraction. The first lightkeeper's dwelling was built in 1867 and extended in 1885. In 1923 a new dwelling was built, and the old one was torn down in 1927. Two houses were built for assistant lightkeepers in 1966 and in 1972. The last lightkeeper, Harry Harris, was injured in a severe fire that damaged his house so badly that it had to be demolished.

The East Point lighthouse site has given birth to many stories and legends. The excavations in the woods west of the lighthouse attest to the futile attempts by adventurers to uncover what they believed to be some of Captain Kidd's ill-gotten treasure. Legend has it that, from the lighthouse, German U-boats could be heard recharging their batteries in Northumberland Strait during the Second World War. Cannonballs have been found in the woods, and storms have driven ashore deck plates and girders from the many ships wrecked on the reefs offshore. An unfortunate victim of one of these wrecks is buried nearby.

The extremely well preserved lighthouse testifies to the skill and practicality of the local carpenters who designed and built it. It is also quite sophisticated in the angled door frames and sculpted and inclined balustrades that react to the tapering of the exterior walls. The 64-foot (19.5-metre) tower is very sturdily built of 4" x 10" (10.2 x 25.4 cm) whip-sawn studs on 12" x 14" (30.5 x 35.6 cm) sills. The corner posts are 10" x 14" (25.5 x 35.6 cm), and some of them are 45 feet (13.7 metres) long. The octagonal structure, built without a basement and braced by ship's knees at the corners, supports about 11 tons (10 tonnes) of wood, steel and glass. In 1968 a 400-watt mercury vapour lamp was installed.

Above and left: EAST POINT LIGHTHOUSE DETAILS. (LS)

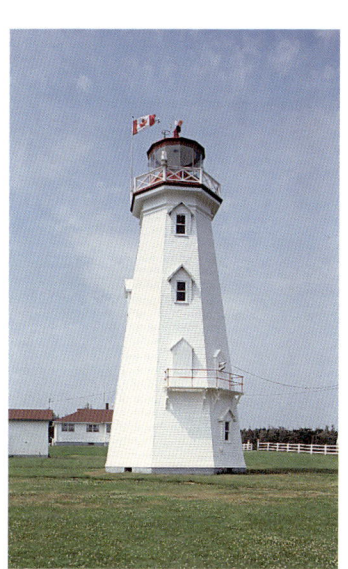

EAST POINT LIGHT. (LS)

Lighthouses

It operates automatically year round, with a range of 20 nautical miles.

East Point lighthouse is a colourful and well-maintained example of a nineteenth-century wooden lighthouse built in Atlantic Canada. Its striking facades and interior, shingle cladding and beautiful surroundings make it one of Prince Edward Island's most treasured historic landmarks. An interpretive centre and craft shop in the fog alarm building welcomes visitors during the summer months.

EAST POINT LIGHTHOUSE RADIO AND FOG ALARM BUILDING. (LS)

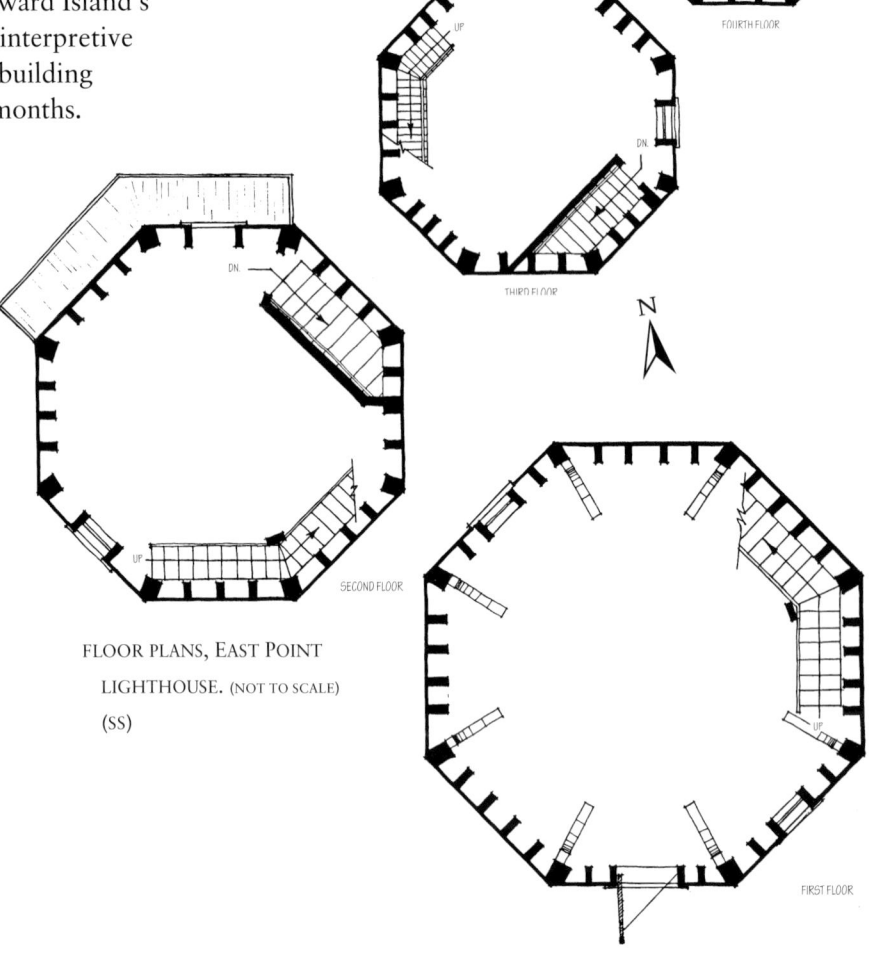

FLOOR PLANS, EAST POINT LIGHTHOUSE. (NOT TO SCALE) (SS)

A Light in the Field

32

Fishery Buildings

(LS)

The Prince Edward Island fishing industry experienced its most significant growth in the period 1850-1885, with the emergence of the mackerel fishery and its requirement for wharves, stages and fish sheds. It really flourished with the decline of the shipbuilding industry and the concurrent lobster canning boom of the early 1880s. Situated within one of the world's richest fishing grounds, the Island's inshore fishery developed steadily and resulted in a proliferation of coastal fish and lobster canneries. In 1903, Prince Edward Island had 190 of them. In the early 1900s, Island fishermen began to unionize. The first union was formed in Tignish in 1925, and the first Acadian fishermen's co-op was founded in 1938. Fishing and processing mostly herring and lobster for both domestic and foreign markets, the co-ops experienced tremendous growth after the Second World War. In 1954, all the co-ops of the Acadian region united to form the Acadian Fishermen's Co-op Ltd.

Today, fishing is Prince Edward Island's third-most-important industry. Northumberland Strait to the south and the Gulf of St. Lawrence to the north

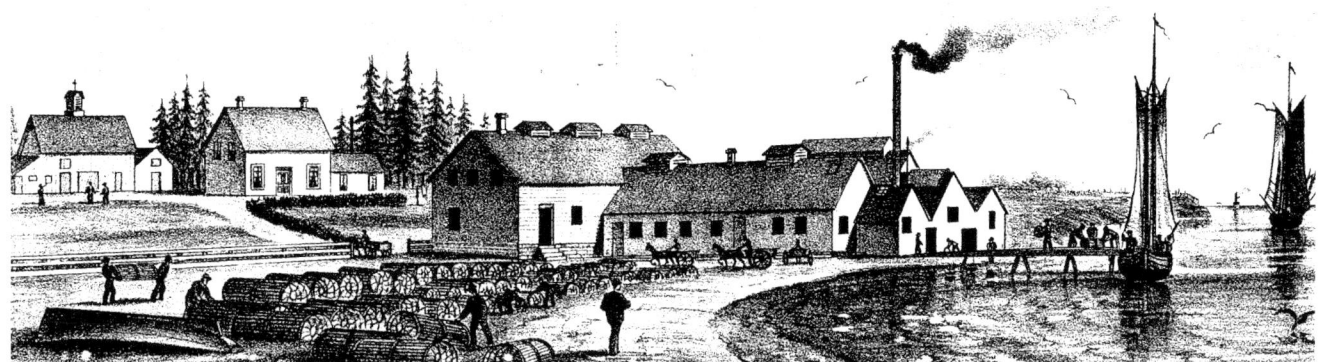

THE RESIDENCE AND LOBSTER FACTORY OF JOHN CAIRNS, WHITE SANDS, CIRCA 1880. (MA)

ANNANDALE. (LS)

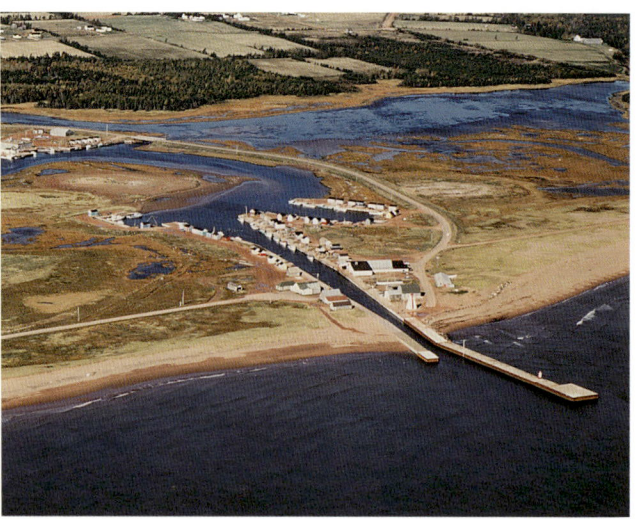
TIGNISH RUN. (LS)

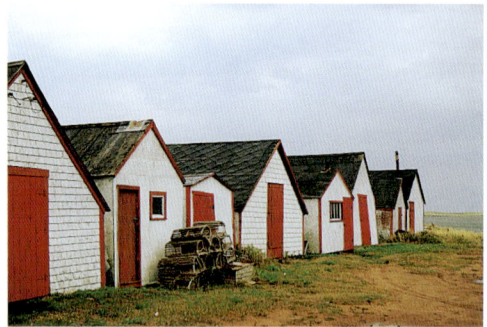
FISH SHEDS, SAVAGE HARBOUR. (SS)

are fished by boats from small Island villages like Tignish Run, in Prince County. Over 30 varieties of fish (predominantly crab, lobster, herring, scallop, smelts, oysters, gaspereaux, mackerel and cod) are landed at small fishing ports like Naufrage, in Kings County. The lobster fishery is significant — over 25% of Canada's lobsters are landed on Prince Edward Island, and the Island is famous for its lobster suppers. Island families have fished for generations from small outports such as Annandale, in Kings County. The dredging of the harbour mouth is a frequent necessity at these coastal ports, where currents and tides deposit silt and sand from coastal erosion.

The harvesting and processing of Irish moss, a staple in the production of ice cream, has become a viable local industry in villages such as Miminegash, (see opposite page) in Prince County. The gathering

A Light in the Field

34

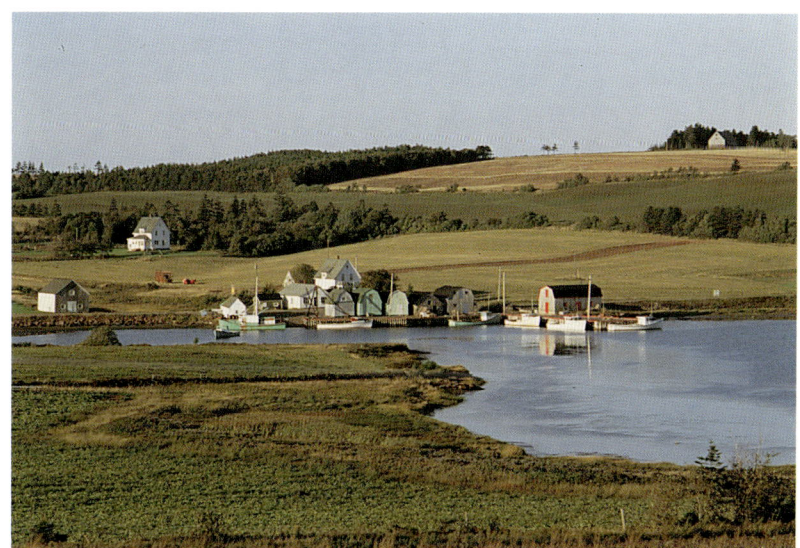

French River Harbour. This small inland port at French River, set in the rolling farmlands, is one of the most picturesque on the Island. (SS)

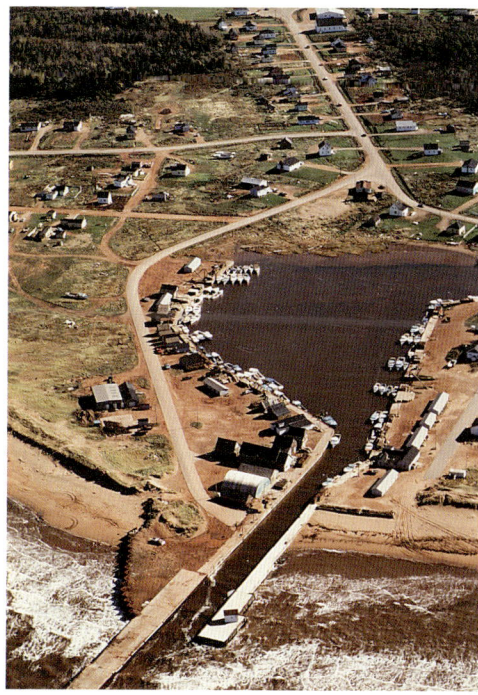

Miminegash. (LS)

of this moss, usually on horseback in the shallow surf, has become somewhat of an attraction in itself. The Island is also famous for its oysters, particularly from the Malpeque area and oyster and mussel farms are proliferating around the Island. Sport and deep-sea fishing have also grown dramatically on the Island since World War II, and the boat-charter trade in the summer is substantial. North Lake (see page 36) is a frenzy of activity when the tuna are running.

The dockside architecture prevalent in the numerous fishing communities that dot the Island's coastline possesses a simple, rugged charm, with an obvious appeal to the many tourists who visit Prince Edward Island each summer. The wharf buildings, fish sheds and processing plants are of a peculiar functional architecture, constructed at harbour's edge or on timber pier foundations or piles. Function dictates form in these buildings, and their style varies little from place to place, decade to decade. Many of these buildings were built well over 100 years ago, while others are converted barns, some with gambrel roofs, that have been transplanted at dockside. Remarkably well-preserved despite the ravages of tides and time, these buildings are used

Fishery Buildings

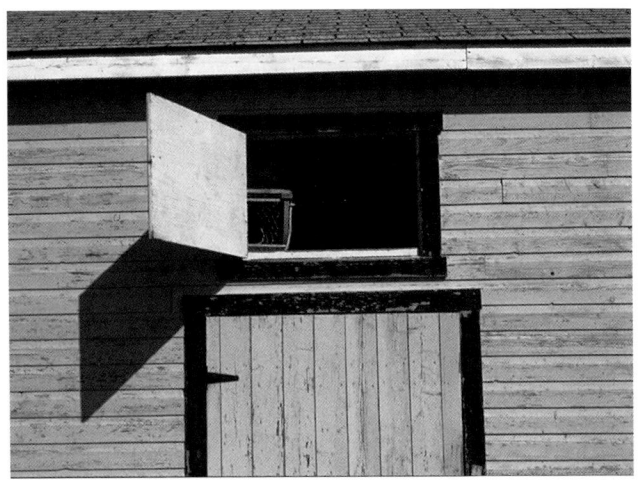

FISH SHED. (LS)

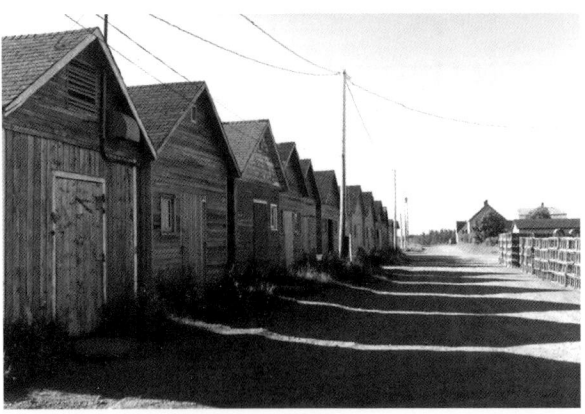

ANNANDALE SHEDS. (SS)

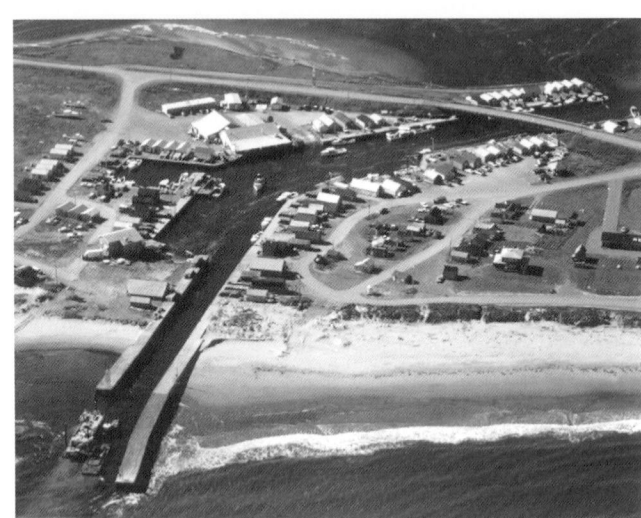

NORTH LAKE. (LS)

for storing fishing gear, nets, traps and bait, as office space and as facilities for salting fish. A variety of building styles can be found on the wharf, from simple, gabled, wood-frame structures to small sheds. Usually, these older buildings are mixed in with newer, pre-fabricated metal sheds or processing plants.

A Light in the Field

Acadian Fishermen's Co-op, Abrams Village

The Acadian Fishermen's Co-op actually originated in nearby Egmont Bay in 1938. In that same year, the Union of Fishermen of Egmont Bay built their first lobster packing plant, a 30' x 70' (9 x 21.3 m) two-storey building on cedar posts, in Abrams Village. After the fishermen's co-ops of the Acadian region united in 1954 to form the Acadian Fishermen's Co-op Ltd., their business grew rapidly, and they decided to expand their operations. In 1971 they built a new processing plant next to the original, which is still in use. Its simple, functional lines project unobtrusively 250 feet (76.2 metres) from shore.

ACADIAN FISHERMEN'S CO-OP, ABRAMS VILLAGE. (LM)

Fishery Buildings

North Rustcio Harbour. (LS)

A Light in the Field

Court Brothers, North Rustico

William Court, a grandson of the Court family that immigrated to the North Rustico area of Prince Edward Island from Stratford, England, in 1825, established Court Brothers fishery in 1865. He fished mackerel, lobster and cod and sold or salted them right at the wharf. When William died in 1934, he left the business to his son Beecher Court, who remained one of the kingpins in the development of the North Shore fishery until his death in 1980, at the age of 91. Beecher, in turn, left this thriving business to his four sons. Under the direction of Quentin Court, the four brothers operate a fleet of three lobster boats out of Rustico Harbour. One of these boats is used for fishing mackerel or for taking some of the many tourists that visit the wharf each summer for deep-sea fishing excursions.

The wharf buildings are constructed on timber pier foundations. Some were built on site over a century ago, while others, converted from other uses, have been moved here. Court Brothers use these buildings as offices, for storing fishing gear and bait, and for salting fish.

COURT BROTHERS, NORTH RUSTICO. (SS)

Fishery Buildings

Basin Head Museum

The museum at Basin Head, opened in 1973, is owned by the Province of Prince Edward Island and operated by the Prince Edward Island Museum and Heritage Foundation. Part of this complex of buildings is the restored Smith fish cannery just down the hill from the museum, at harbour's shore. It houses salt-water aquariums and a coastal ecology exhibit. The main museum, a newer building overlooking a spectacular white sand beach, contains dioramas, photographs, old canning equipment and small-boat exhibits. These depict the development of the Island's inshore fishery and its lobster and fish canneries. There are also reconstructed fishing shacks near the wharf, used to store bait, traps and other fishing gear.

Various social, educational and cultural events are staged at Basin Head Museum throughout the summer months. Local fishermen still use the port at Basin Head, and lucky visitors can sometimes catch a glimpse of the fishery's present as well as its fascinating past.

BASIN HEAD MUSEUM. (LS)

A Light in the Field

Smith fish cannery, Basin Head Museum. (LS)

Fishery Buildings

Clockwise from above: Acadian log barn reconstruction, Mount Carmel. (SS)
Pioneer barn with star-shaped vent, Annandale. (LS)
Log barn reconstruction, Selkirk Settlement, Eldon. (SS)
Pioneer barns near Flat River. (LS)

A Light in the Field

Barns and Farms

A midsummer excursion through the lush rolling countryside of Prince Edward Island is a stunning visual experience and a confirmation that the province is one of the most healthy and prosperous agricultural locales in North America. The numerous farms, ranging in size from the small, family-owned mixed farms to the large potato-processing conglomerates, are an integral part of this unforgettable landscape. The red, white and weathered grey hues of the farmhouses and barns enrich and complement the distinctive greens, rust-red browns, yellows and blues of the Island's rural panorama. In full bloom, the results are breathtaking — an artist's delight.

There are many kinds of farms on Prince Edward Island and at least as many varieties of barn forms. The earliest type of barn on the Island, built primarily by Acadians and Scottish settlers, was a simple lean-to or gabled log structure that housed livestock, farm implements, hay and other grains. Few of these late-eighteenth-century structures have survived the ravages of time. The most common style of barn presently found on the Island is a three or five-bay, steeply gabled, one-and-a-half- or two-and-a-half-storey English or "pioneer" barn. Its length is usually twice its width, and the main entry is usually centred on one of the long sides, although gable end entries are also quite common. The next most prevalent Island barn type is the Dutch or "pole" barn, featuring a side-aisle floor plan derived from an ecclesiastical or "basilican" configuration. This is

DUTCH BARN, BASILICAN PLAN, STANCHEL. (BG)

WEATHERVANE, CHARLOTTETOWN. (LS)

GAMBREL BARNS, MILTON. (LS)

Barns and Farms

43

a much larger building and is most suited for dairy farming, horse ranching or the stabling of other livestock. The gambrel-roofed barn, usually two-and-a-half or three-and-a-half storeys high and with more usable floor space under the roof, is a more recent development, built from about the year 1900. Gambrel-roofed barns were built primarily to stable livestock — cattle, horses, hogs or poultry — with hay and other grains often stored on the upper floors. A very few Pennsylvania style or "bank" barns exist, notched into a hillside, with a masonry foundation and cantilevered upper stories. Stone barns and barns that contain living quarters for the farm family are also extremely rare. There is little evidence of the existence of threshing floors in surviving Island barns, probably due to an early proliferation of grist mills in many of the small rural communities.

There are many types of farm buildings on Prince Edward Island with their own distinctive architecture, and each has a specific use:

a) Octagonal barns. Precious few examples survive, mostly in the eastern part of the Island (see page 52). Initially built as millwright's workshops and machinery sheds, one of these, at New Perth, has been converted into a house.

b) Fox pens and observation towers. The great silver fox ranching boom of the early 1900s in western Prince Edward Island generated not only many fine houses but also a peculiar type of low, light wood frame pen and an even more unique tower. Tall and slender, it was used by the fox rancher to unobtrusively observe the breeding fox pairs (see page 57).

ELM WOOD FARM, FREETOWN, LOT 25. (MA)

A Light in the Field

c) Potato barns. The storage of the Island's greatest export requires strict temperature and humidity control. A long, low, windowless building with a gambrel roof and earth berms to below the eaves, the potato barn developed in the early nineteenth century and functions on the principles of a root cellar.

d) Tobacco barns. The Island's tobacco farming industry, based largely in Kings County, requires a specialized barn environment for sorting, processing and drying the tobacco leaves. Most of these buildings are modern; few date from before World War II.

e) Hay barracks. These consist of a small hipped canopy that can be raised or lowered on a frame of four corner poles. Also known as hay mows, they are used to protect hay in the field or farmyard (see page 61).

f) Pumphouses and wellhouses. These small buildings were often round or octagonal. They provided a visual focal point in the farm court-yard and in many cases were the object of a farmer's penchant for decoration (see page 52).

POTATO BARN, WILMOT VALLEY. (LS)

g) Piggeries and henhouses. Smaller, lower variations of the pioneer barn were sometimes built to segregate pigs and poultry from the other farm animals. These were well lit, with extra windows, and had plenty of natural or mechanical ventilation.

h) Machine sheds. Some farmers stored machinery in a separate shed-like structure erected for this purpose. Successful farmers or shipbuilders, such as Captain William Richards, built more elaborate carriage houses, which could also stable horses (see page 54).

HAY BARRACKS, LAKE VERDE (SS)

HENHOUSE, BARRETT FARM, EAST WILTSHIRE. (SS)

Barns and Farms

i) Silos. Most silos on Prince Edward Island are of the modern, pre-fabricated, corrugated steel variety. Very few of the older timber-framed silos, usually built as a round or square addition to a barn, survive. A very good example stands at Strathgartney, in Queens County (see page 59). A few concrete silos can still be found in Prince County.

Concrete silo near Knutsford. (RT)

j) Kilns. Most of the old limestone kilns have been overgrown, and only traces of these sandstone structures, used to supply lime fertilizer for the fields, can still be found.

Prior to the availability of modern, pre-fabricated light steel barns to accommodate their expanding operations, Island farmers often extended their barns in one or more of the following ways:

1) by extending the building along its longitudinal axis, through the addition of a bay at either end.

2) by constructing a shed addition to one of the barn sides, usually below the eaves line.

Few, if any, Prince Edward Island barns were built originally as saltboxes.

3) by building a connected wing, or ell, abutting the main barn at right angles. These additions usually had the same roof type as the

Top: Connected barns, South Melville. (SS)
Above: Shed additions, St. Chrysostome. (LS)

A Light in the Field

LINEAR BARNS, PICKETT FARM, NEW ANNAN. (SS)

original, but the roof line was not always built at the same height.

4) by expanding upwards, raising the roof and, in many cases, adopting a gambrel style.

5) through the addition of a distinct barn structure to the farmyard for a specific purpose, such as a piggery or hen house.

6) by converting a building of another type, such as a defunct schoolhouse, railroad station or farmhouse, into a barn. Farmers sometimes showed great ingenuity in hauling these buildings to their property. Today we can also see many examples of barn buildings that have been converted into dwellings or commercial or industrial buildings.

The layout of the farm outbuildings relative to the farmhouse was usually well calculated and reflected a consideration of all the geographical and climatic variables on Prince Edward Island. Topography (never extreme), drainage, orientation, wind direction, indigenous vegetation and foliage, soil conditions, water sources and access roads were all considered when farmers planned their barnyards. These barnyards fall into two basic configurations — either a linear arrangement of barns or a rectilinear courtyard, often a two-sided ell but sometimes a three-sided court. This courtyard was usually protected from the prevailing northerly winds, either by the barns themselves or by a planned windbreak of trees or a hedgerow, which would also reduce energy costs of farm buildings and increase crop yields. Occasionally, a linear barn arrangement would

RECTILINEAR FARMYARD, NEAR PINETTE. (LS)

RANDOM FARMYARD, GUERNSEY COVE. (LS)

Barns and Farms

assume a curve at one end, probably for additional weather protection.

Random arrangements of outbuildings are not uncommon on Prince Edward Island, but the barns themselves were usually arranged in parallel fashion, roughly defining several adjacent courtyards. These random configurations were often dictated by fire safety precautions. At the centre of many barnyards was the well, so located to efficiently water the livestock. It was also the only source of water to fight a fire. Many an Island barn has been lost to fire, sometimes with a catastrophic loss of livestock, crops and expensive machinery. Barn fires have numerous causes — from lightning strikes to electrical sparks to spontaneous combustion — but one thing is certain: old barns were not built to the same fire safety standards as farmhouses and contained more flammable materials. It is not surprising, then, that the rate of attrition for barns is so high, relative to that of farmhouses. Many unused barns, though, if they are not razed by fire, simply sink into the ground, the victims of time and neglect. It is also interesting to note a chronological sequence of buildings on a typical farm. In many cases, the original farmhouse, if it has not been converted into a barn, stands forlorn and neglected next to a more contemporary, energy-efficient house and adjacent to pre-fabricated, fireproof steel barns.

One of the more interesting aspects of Island farms is the variety of fences, posts and gates that define the individual properties. The earliest fences were built with material cleared from the fields: tree stumps, logs, rubble or field stone. Today, there remains evidence of only the latter. The most common fence on the Island prior to World War I and the advent of barbed wire was the rail fence. It was usually built six or seven rails high and in 12-foot (4-metre) sections. The straight rail fence was most common, with vertical or crossed posts at the intersections, but in some areas, the zigzag, or "snake" configuration was popular. Sometimes the rails were split in two to economize on timber.

LINEAR

ELL

COURT

RANDOM

A Light in the Field

There is evidence of combined fieldstone and rail fences on the Island and hedgerows can still be found defining farm boundaries. Most fences today are wire, but Islanders have retained a way of personalizing them with lathe-turned fence posts. Often ornate and brightly painted, these posts would be turned at the nearest water-powered lumber mill, although some farmers owned their own lathes and powered them with their tractor's drive train. More prosperous farmers sometimes chose to articulate their lane entrances with elaborate iron gates, in many cases the work of the local blacksmith. They were often set between carved sandstone or intricate lathe-turned gateposts that usually carried a nameplate or some other inscription (see page 50).

The Island's pioneer farmers often brought with them sketches or concepts of barn construction and farm layout from southern England, Ireland or the Highlands and Hebrides of Scotland. In the early 1800s, the design and construction of Island barns and other farm buildings were heavily influenced by farming practices in New England, through the influx of United Empire Loyalists and the proliferation of agricultural periodicals such as *The New England Farmer*. Shipbuilders who settled and prospered in the west central region of the Island in the late 1800s applied shipbuilding techniques to the construction of their barns. The English barn and elongated "longhouse" form underwent a transitional development in New England and eastern Canada, and the Dutch basilican barn also established its early footings in New England. On Prince Edward Island, connected barns serving different functions often have a common roof line; this configuration is also common in Quebec, but there, living quarters are often attached to one end. New England's connected barns have varied and staggered roof lines and a distinct farmhouse linked to one end, whereas the farmhouse on Prince Edward Island has always remained separate, probably for fire safety considerations.

Island farmers built very solid barns. The early pioneer barn was built on a post-and-beam system with rafter roof

SNAKE RAIL FENCE, SKINNERS POND. (LS)

ROOFLINE EXTENSION, ROBERTSON BARN, MUNNS ROAD. (KM)

Barns and Farms

ORNATE GATE, DRAKE FARM, HAZELBROOK. (SS)

FENCEPOSTS, LING FARM, NEW GLASGOW. (SS)

HEX SIGN, MILTON. (SS)

framing (see page 51). The heavy framing members were often hand-hewn or whip-sawn, and they were connected with mortise-and- tenon joints pinned with hardwood dowels or tree nails. To withstand the heavy loads in the upper hay loft and for lateral bracing, knee braces, ingeniously cut from a tree branch or root, reinforced the post-and-beam superstructure. Sometimes a straight diagonal timber brace was mortise-and tenoned into the post-and-beam. These pioneer barns had a feature on Prince Edward Island that was unusual but highly practical: the steeply pitched gable roof line was extended along the ridge at one end to house a block and tackle or other pulley system used to hoist hay into the upper loft. In many cases this extension was well-developed and provided shelter to those working below.

Barn roofs display other interesting features. Cupolas along the ridge provided ventilation and light and, when surmounted by a cast iron weather vane, became a prominent decorative feature (see pages 43 and 53). Roof dormers, usually triangular, were common, and many were enhanced with decorative gingerbread, repeating the Victorian Carpenter Gothic details of the adjacent farmhouse. Decoration of Island barns was otherwise minimal: an occasional hex mark or wall mural. The traditional reds, whites, greens, browns and blacks and the greys of the weathered planks and shingles make up the predominant colour scheme. Occasionally, a wall of an abandoned barn has been used as a brightly coloured billboard. The arrangement of doors and windows on the barn facades, whether by accident or by design, gave the buildings rhythm, charm and, in some cases, a touch of humour. Some barns had ramps graded up to a second-storey entry, and many other farm buildings

A Light in the Field

were built over a full basement or root cellar. The foundations were constructed with dressed or ashlar Island sandstone, found loose in the fields or quarried locally. Because of the unstable nature of the sandstone, however, many of these foundations have had to be replaced with poured-in-place concrete or concrete block.

Pole barns built on the basilican plan are most common on the eastern end of the Island. Construction consisted of two or four rows of interior columns supporting trusses or a truss-like framing system that cantilevered beyond the outside column lines to form the side aisles. The later gambrel barn, most popular in Queens and Prince counties, was of a much lighter frame construction, with a more intricate roofing system. All of these barn types, and even some of the surviving log barns, are sided with rough sawn vertical or horizontal planks, sometimes as wide as 18 inches (46 centimetres). On many barns, an outer layer of pine or cedar shingles or shakes has been applied. More modern barns feature clapboard or shiplap siding. Roofing, now mostly replaced with asphalt shingling or corrugated metal, was done almost exclusively in pine shingles.

Much has been written about the North American barn raising bee and the spirit of civic co-operation that it fostered. In Prince Edward Island, people sometimes came from right across the Island to assist in a barn's construction. Because of the short growing season, time was usually of the essence. These

PARTIAL SANDSTONE FOUNDATION. (PEINP)

GAMBREL ROOF, MOUNT HOPE. (BG)

DOWELLED FRAMING CONNECTIONS, NORTH MILTON. (BG)

Barns and Farms

barn raisings were often the highlight of the social calendar as well, with plenty of food, drink and entertainment on hand. Pioneer farmers in Prince Edward Island survived many a hardship — clearing and cultivating land in a strange new country and in an extreme climate — and a barn raising gave old and young a splendid opportunity to combine labour and fun.

Today, the traditional Island family farm is being threatened by the encroachment of large agricultural conglomerates and more progressive scientific farming techniques. Good farmland is being turned over to service a burgeoning tourist industry, and questionable soil management and virus monitoring by government authorities has cast a shadow of uncertainty over the future of the small, mixed family farm in Prince Edward Island. Traditional farm buildings are being replaced by garish and foreign tourist complexes or by modern, lightweight, pre-fabricated steel structures. Even so, some farmers, particularly on the extremities of the Island, seem to be relatively unaffected by these changes. They continue to build in more traditional ways, as well as maintaining and using the simple, elegant and practical buildings that were built with so much pride and forethought.

OCTAGONAL BARN, BALDWIN ROAD. (LS)

Octagonal barns are extremely rare on Prince Edward Island. This one was built circa 1885 by James Moar to store the wagons and sleighs that he manufactured. About 25 feet (7.6 metres) wide, it is modelled after similar structures in the Orkney Islands off the north coast of Scotland, where James's father emigrated from in the early nineteenth century. Of the five other octagonal barns that he built, only one survives, converted to a house in New Perth. Alan Corcoran, the present owner of the Baldwin Road barn, uses the building as a garage and machinery shed. The small pumphouse that he added to the front caps a circular sandstone well.

A Light in the Field

Right: GILLIS OUTBUILDINGS, LYNDALE. (SS)

This barn shows a simple sophistication in its line and form that one often notices in Island barnyards. The small octagonal building is quite rare and was used as a wellhouse, dovecote or henhouse. Roger Gillis is the present owner. Although the barns have been vinyl-sided, they retain their practical, essential form.

Above: GALLANT BARN, ABRAMS VILLAGE. (LS)

Joseph Gallant's farm is a most colourful place, even though his barns are the more traditional greys of weathered shingles. The doors and windows of the front facade are combined in an eccentric and rhythmic way. Most of the barns were built around 1910, but later shed additions to the back of them have created more contemporary architectural forms. The barns define a perfect courtyard and, up until 1955, were used to stable livestock. Mr. Gallant, a woodcutter, now uses them to store wood and machinery.

Bottom: GILLIS BARN, MISCOUCHE. (LS)

This barn on Route 11 in Miscouche was built in 1924, replacing a similar one that had burned down two years earlier. Destruction by fire was not an uncommon fate for many of the large gambrel-roofed barns of the area. The second barn was built for Urban Gillis, a successful fox rancher, potato farmer and author, and it is presently owned by his son, Donald, who uses it mostly to stable racehorses. The building is well appointed, with iron stalls and hardwood wainscoting. The exquisite cupola roof vents highlight the architectural skyline of Miscouche, near the magnificent twin spires of St. John the Baptist Roman Catholic Church.

Barns and Farms

Above: HAY BARRACKS, LAKE VERDE. (LS)

The hay barracks (or hay mow) is an endangered species on Prince Edward Island, with only a handful of good examples remaining and even fewer in actual use. Thought to originate with the Acadians or the Irish, the hay barracks was designed to make hay more accessible than it would be in a barn. These well-preserved examples in Lake Verde illustrate how the ingenious elevating canopy protects a small quantity of hay from the weather

Below: MOORE BARNS, WESTMORELAND. (SS)

This group of dairy barns is owned by Wrixon Moore, the fifth generation of his family to farm here since John Moore arrived from Suffolk, England, in 1830.

A Light in the Field

Above: ROGERS BARN, BRAE. (SS)

Although this magnificent articulated barn was seriously damaged by fire in 1992 and had to be torn down, its Gothic presence is hard to forget. It was built circa 1885 by William Thomas Rogers and later embellished by his son, William Russell Rogers, a successful fox, horse and cattle rancher. The ornamental filigree and finials along the roof ridge and dormer crests created an elegance that was more commonly found on high-style Victorian houses.

Below: RICHARDS CARRIAGE HOUSE, BIDEFORD. (CIHB)

At first glance or from a distance, this building appears to be a typical Island barn. On closer inspection one finds a carriage house with some remarkable detail: hand-carved shingles in intricate patterns, flared eaves and corner eave brackets. Built around 1865 by Captain William Richards, a prominent shipbuilder and exporter, in an area renowned for its shipbuilding, the carriage house has survived a succession of different owners. It was stained red in 1990 and is presently used as a horse barn.

Barns and Farms

Ramsay Farm, Montrose

In 1906 a flue fire levelled the original Ramsay family homestead in Montrose. It was immediately rebuilt by Bertram Ramsay, who had a considerable stake in the successful 100-acre (40.5 hectare) dairy farm. So impressed were neighbours with Mr. Ramsay's house-building that he was immediately asked to build three others, as well as a number of bridges, wharves and breakwaters in the area.

Bertram was a descendant of the Ramsays who were shipwrecked off Malpeque on the *Annabella* in 1770. His grandfather, Donald Ramsay, had come from Freeland to settle in Montrose in 1850.

Bertram was also a skilled barn builder, as the long rambling dairy barns behind the house attest.

RAMSAY FARM, MONTROSE. (LS)

There is a remarkable unity of style between house and barns. Many similar construction techniques were used in both, but the Ramsays built for flexibility as well. In addition to dairy farming they have, at times, grown potatoes and corn.

Fred Ramsay, one of Bertram's thirteen children, expanded the farm to 300 acres (121.5 hectares) and raised prize-winning Hereford cattle. In 1980 Mr. Ramsay sold the farm to a potato farmer named Garth Wilkie. Mr. Wilkie has extensively renovated the farmhouse but the barns have remained essentially intact.

MAIN BARN, RAMSAY FARM, MONTROSE. (LS)

A Light in the Field

Milligan Farm, Northam

When Robert Milligan of Dumfries, Scotland, settled in Prince Edward Island with his large family in the early 1800s, little did he know that his grandson, James Edgar Milligan, would eventually write one of the most dramatic and successful chapters in the Island's economic history.

James's father, Thomas Milligan, was an enterprising man who ventured into the Klondike in search of gold. It was during a trip to Alaska to tend to his ailing father's claims that James met George Morrison, a Pennsylvanian who had opened a trading post and fox ranch in the wilds of Alaska. In 1914 the two became partners and moved their silver fox breeding activities to Northam, Prince Edward Island. They began with 15 pairs of foxes, and six years later they had 100 pairs. At its peak the farm housed as many as 305 pairs. The original mixed farm of 25 acres (10 hectares) had swollen to 185 acres (75 hectares), with as many as 235 fox pens and up to 2000 foxes, bred primarily as breeding stock but also for their pelts. Milligan and Morrison established a chain of fox farms across Canada and the USA that numbered thirty-four in the early 1930s. James Milligan was responsible for the local breeding operations, and Morrison, a super salesman, acted as service manager and sales consultant. They became very wealthy and were so successful that in 1926 they made the largest single shipment of live foxes to the USA ever recorded — 855 foxes in three rail freight cars, valued at about $800,000.

MAIN BARN, MILLIGAN FARM, NORTHAM. (LS)

Their profits encouraged them to expand into dairy farming, and in 1926, amidst great fanfare and some seven thousand invited guests, they opened a giant new dairy barn. Athletic events and entertainment highlighted this day — "a day which put Northam on the map," claims the *Prince Edward Island Agriculturist*. The same article describes the new barn as "the largest and most modernly equipped barn in the Maritime provinces." It was and still is an impressive structure, three stories tall, with intersecting gambrel roof lines and elaborate cupola roof vents, now mechanically operated. It was designed

Barns and Farms

remain, including the farm workers' dormitory. Jim Milligan, James's son, continued to raise foxes, as did his son-in-law, Bill Douglas, but eventually the farm became essentially a dairy operation. In 1990, Bill Douglas sold this historic farm to Allison Dennis, who, in partnership with Paul Dillon, raises beef cattle and grows potatoes.

(LS)

and built by James Milligan and the renowned builder Wilfred Maynard. In 1931 an oval horse racing track was built right on the farm property, and the grandstand, which seated 2500 people, could only partially accommodate the huge crowd that attended the opening. For many years this rural track operated successfully, even at night under power from the farm's own generator.

In 1933, on their way to a silver fox school in Illinois, James Edgar Milligan and George Morrison were killed in a car accident near Buffalo, New York. The Milligan and Morrison affiliated ranchers, however, were able to survive this catastrophe by having previously selected a succession of managers that continued to promote the growth of the organization until the advent of Second World War.

Today, the race track, fox pens and watchtower are no more, but some of the fox farm buildings

Fox tower, Milligan farm, Northam. (LS)

A Light in the Field

58

Strathgartney, Bonshaw

Strathgartney, meaning "valley in the hills" in Gaelic, is named after the birthplace of David Stewart in Perthshire, Scotland. Mr. Stewart was one of the first land proprietors in Prince Edward Island, and by 1831 he had claimed about 80,000 acres in all three counties. In 1846 he persuaded his son, Robert Bruce Stewart, to come to Prince Edward Island to manage his huge estate. Robert and his family lived for a while in Charlottetown but fell in love with a hilly area in Lot 30 in Queens County. In 1849-50 he built his country home there and called it Strathgartney, and it
stands today as one of the few remaining homes of the original land proprietors. Robert Bruce Stewart adopted Strathgartney as his principal residence in 1863, and from that homestead, he managed his family's widespread holdings: collecting rent, building roads and becoming deeply involved in the controversial Land Question of that period. In 1875 the Land Purchase Act was passed, and the large proprietors were compelled to sell all their land, with the exception of a relatively small acreage. Robert Bruce Stewart was allowed to keep 500 acres (202 hectares), and he chose to retain Strathgartney, which by then had become a highly successful mixed farm under the management of his son, Robert Bruce Stewart, Jr.

The farmhouse itself is a rambling frame house built on one of the highest sites on Prince Edward Island. Its scenic views of the Northumberland Strait are breathtaking. The house has seen many physical changes over the years and is actually two centre-gabled buildings joined together, the second dwelling having been built around 1900. In 1908 the servants' quarters were removed, the kitchen area altered and a veranda and western entry added. The ground floor now contains the kitchen and pantry, breakfast room, dining room, parlour and library. On the second floor are the master bedroom, children's bedrooms and bathroom.

SILO, STRATHGARTNEY, BONSHAW. (SS)

STRATHGARTNEY BARNYARD, BONSHAW. (LS)

Barns and Farms

The third floor used to house the many nineteenth-century antiques and artifacts that Robert Stewart, Sr., brought from Britain, including period pieces of rosewood and walnut, china, pottery, paintings, a wall tapestry and the old Stewart clan bagpipes. Some furniture and the bricks for the main fireplace were made on or near the homestead. The Stewarts were also accomplished gardeners, and the surrounding grounds with ornamental trees and shrubs imported from Europe are impressive in full summer bloom.

The farm buildings on the homestead were built in the early 1850s. These sturdy gabled buildings form a neat courtyard just east of the house. The grain silo on one end of the main barn is one of the earliest on Prince Edward Island. The original spruce shingle cladding on these barns is remarkably well preserved. Since the farm became inactive in the late 1950s, the barns have alternately housed a gift shop and a museum of old wagons, farm machinery and implements of yesteryear.

The Stewart family lived for generations at Strathgartney until the death of the Honourable W.F. Allen Stewart, MLA, in 1955. It was acquired by Mr. and Mrs. Keith Pickard in 1960, who operated it as a popular tourist attraction, golf course and campground until they sold it in 1984. Unfortunately, much of the period furniture was sold by auction in 1980. A family named Ryan owned Strathgartney until 1986, when a businessman from Ontario, Gerry Gabriel, purchased it with the intention of restoring it and operating an inn. Some of the outbuildings were converted to living units and shifted around the site. The barns were not a priority and were allowed to deteriorate. In 1994 the province of Prince Edward Island acquired Strathgartney, and a year later the Strathgartney Foundation was formed and became its sole owner. Its mandate is to preserve and interpret the estate and its natural habitat.

STRATHGARTNEY. (LS)

A Light in the Field

Orwell Corner

Orwell was named by Surveyor-General Samuel Holland in 1766 to honour Sir Francis Orwell, Britain's Minister of Plantations at the time. A typical rural agricultural community of mid-nineteenth century Prince Edward Island, it was settled initially by Scots. Some came from the Selkirk settlement of 1803, and others were Scottish Protestants who arrived on the *Mary Kennedy* in 1829 and who settled at first in the Uigg area. They were followed in mid-century by the Irish — mostly Kellys and Hugheses. Among the Irish were Dennis and Richard Clarke from County Galway, who settled in nearby Orwell Cove in 1856. A few years later they moved to Orwell, and in 1864 they opened a general store. They built a house as an addition shortly thereafter and operated a post office behind the house from about 1900. Gradually, a community formed around them. A Presbyterian church was built in 1861, and its rear transept, choir and organ platform were added in 1892. In 1925 the Orwell congregation joined the United Church of Canada. The present schoolhouse, built in 1895, is the third school on the site. Together, these buildings

ORWELL, CIRCA 1880. (MA)

SNAKE FENCE, BARN AND HAY BARRACKS, ORWELL CORNER. (LS)

Barns and Farms

BARNYARD, ORWELL CORNER. (LS)

formed the commercial, social, religious and educational components of a growing Island village. All are restored, and all but the church are in use.

Orwell's restoration was conceived in 1972. The Orwell Corner Corporation was founded that year, and, with the guidance of the Prince Edward Island Heritage Foundation and the provincial Department of Tourism, work began immediately. Orwell Corner was opened in 1973 as a Prince Edward Island Centennial project, and it has been growing ever since. A blacksmith's shop (1976) and a shingle mill (1977) have been added, built on plans developed from the study of existing models. The original community hall burned down in the 1950s but was rebuilt in the mid-1970s.

The community hall at Orwell is still the centre of many social, cultural and educational activities and events that attract both Islanders and tourists. The artifacts and period furniture in the house, store and millinery shop upstairs attract many visitors in the summer, but what seems most appealing is the fact that Orwell Corner still functions as an active agricultural community, as it did around 1895. Mixed crops and grains are grown nearby. One of the barns, previously a warehouse near the store, was moved to its present location in the barnyard and is now used as a wagon house. In it and surrounding it are many vintage buggies and sleighs and fine examples of early farm machinery. The main central barn houses livestock, a threshing floor and grain and straw. A small octagonal henhouse was built at the end of this main barn in the early 1990s. Until very recently, a hay barrack stood behind it. Once fairly common across the Island, these unique structures are rapidly disappearing from the agri-cultural landscape.

OCTAGONAL HENHOUSE, ORWELL. (BG)

It is a healthy restoration that functions in accordance with its original design. Orwell Corner Historic Village successfully captures the mood, flavour and activity of a small, rural agricultural community more than a century ago.

A Light in the Field

Mills

Just as the schools and churches were the cultural centres of the emerging Prince Edward Island communities, the local grist, woollen and lumber mills that supplied the manufactured goods were their economic centres. In 1800 there were four saw mills, ten grist mills and four other mills of undetermined type in Prince Edward Island. Sixty years later, these numbers had risen to 176 sawmills, 141 grist mills and 46 woollen mills. There were more grist mills on Prince Edward Island than in any other Maritime province because the soil was more suitable for the growing of wheat. Most of these mills were situated on the banks of rivers or streams and powered by a series of waterwheels and gears. Often the streams had to be dammed and headponds created to ensure enough pressure and volume when water levels dropped in late summer. The water, controlled by sluice gates, was released and conveyed by a flume to turn the main waterwheel of the mill. Rivers and streams did double duty for lumber mills, as the supply of logs was often driven downriver to the mill in springtime. In several communities, sawmills and grist mills shared the same property, and in some cases they drew power from the same waterwheel.

Architecturally, mill buildings were simple, gabled, heavy-framed structures designed around the specialized machinery used in the particular milling operation. Grist mills tended to be three or more

MILL PROPERTY AND RESIDENCE OF GEORGE D. BALDERSTON, NORTH WILTSHIRE, LOT 31. (MA)

BRIDGETOWN MILL. (SS)

Mills

O'LEARY SAWMILL, ABOUT 1910. (PARO)

WATERWHEELS. (*MILLS OF CANADA*)

on stone or timber posts, with the power and gear machinery below in a shallow basement.

Most often a post-and-beam structural system was employed in the construction of sawmills and the timber framing members were sometimes massive — up to 12 to 14 inches (30 to 35 centimetres) square. This was also the case in grist mills, where the grinding wheels and other machinery were extremely heavy. In some mills, joists or planks were laid next to each other on their narrow sides, forming a structural floor. In many cases, the structural members and their diagonal braces were hand-hewn, usually with doweled mortise-and-tenon joints. Decoration was practically non-existent; these were strictly utilitarian, industrial buildings. Most mills were built on a solid stone foundation, sometimes using stone cut directly from the river bed or from a nearby quarry. Sandstone was a plentiful if not a very stable building material on Prince Edward Island.

The number of sawmills reached its peak in Prince Edward Island in the 1870s, at the height of the shipbuilding boom, but declined steadily after that. Each shipyard required a lumber mill and usually a mill pond. Unfortunately, due to the

storeys high, as the milling process was essentially performed in a vertical sequence. The grist mill often had a ramp access at an intermediate level to facilitate the unloading of grain and the loading of the mill's products. Sawmills tended to be longer and narrower and were often only one storey in height, because sawing logs and milling lumber tended to be a linear, horizontal process. The low, shed-like structures were often skeletal, built without outside walls. The sawing floor was commonly raised above grade

A Light in the Field
64

relentless processes of technology, industrialization and the import trade, and the ever-present menace of fire, few mills of any kind remain in operating condition today. Some have been converted into houses or barns. The old mill at Long River has housed a museum and became a tourist attraction. Most early mills, however, have fallen victim to time, progress and neglect. They are poignant reminders of Prince Edward Island's early struggle towards self-sufficiency.

Left: ABANDONED MILL, GLENWOOD. (LM)

ABANDONED WARREN MILL, NORTH RIVER. (LM)

Mills

MacAusland's Mill, Bloomfield

In Bloomfield, Prince County, Harry and Alan MacAusland operate a flourishing woollen mill, making blankets and yarn for sale world-wide. The mill is located on a tributary of the Mill River on the same site as the original water-powered grist and sawmill established by their great-grandfather, Archibald MacAusland, in the 1860s. In 1949, the mill, by now producing woollen goods, was ravaged by fire. Alan and Harry's grandfather, Fred MacAusland, was managing the mill at the time and, shortly thereafter, passed away. His two sons, however, were determined to carry on. Reginald and Edward, the fathers of Harry and Alan, respectively, had the mill rebuilt immediately, on the same plan. They were back in operation within four months, this time under electric power. Architecturally, the mill is plain and functional. The ground floor is essentially designed around the mill machinery that it houses, and the second floor is used for storage and offices. A shop next door sells blankets from the mill and sweaters, mitts, socks and other woollen goods knitted from the mill's yarns by enterprising women of the community.

MACAUSLAND'S WOOLLEN MILL, BLOOMFIELD. (SS)

A Light in the Field

Leard Mill, Coleman

In 1884, the old grist mill on the Barclay Road near Coleman, in Prince County, was purchased by Peter Warren Leard from its builder, James Barclay, and it has remained in Leard hands ever since. Warren Leard, the grandson of P.W. Leard, has successfully operated the mill since 1964, giving up a railway career to take it over from his father, Waldron Leard.

The mill was initially powered by water, first by an overshot wheel and then, around 1910, by turbine. It wasn't until 1954 that the power source was replaced by a diesel engine. The old grind wheels have long been replaced by steel rollers, but visitors still feel as if they're stepping back in time when they enter Warren Leard's neat and tidy mill. Indeed, Warren spends most of his summer, traditionally an inactive time for grist mills, conducting unofficial tours of the premises and repairing his machinery.

The mill building has a simple utilitarian charm and a commanding historical presence. A bright red and white gabled structure of two-and-a-half storeys, it has a ramp entry to the main work area on the second floor. This area is well lit by day with a row of paired six-over-six windows.

The Leards are a milling family, having operated several other grist mills and sawmills and even a hydroelectric generating station in other Island communities. In his prime, Warren Leard could mill up to 100 bushels of wheat a day from his 25-acre (10-hectare) farm. He produced high quality naturally ground flour, bran, middlings, wheat heart and shorts, with no bleaches or chemical additives, for Maritime and local customers, tourists and health food stores. Warren used to also grind wheat for other local farmers and the occasional out-of-province farmer. Milling is just a hobby now, but Leard's Mill is living history — a glimpse into a much simpler past. Of the dozen or so other grist mills that once flourished on the Island, it appears to be the lone survivor.

LEARD MILL, COLEMAN. (LS)

Mills

Ives Mill, North Tryon

The area around North Tryon on the Tryon River has a long and rich history of milling and hydroelectric power. Richard Dawson built a grist mill and sawmill for Thomas Ives in the late 1860s. When Thomas died in 1884, his son George became the owner of the sawmill, and his younger son Charles inherited the grist mill in 1915. By 1902 Charles had also built one of the first rolling mills on Prince Edward Island, and the flourishing mill often ran twenty-four hours a day. Soon after Charles retired in 1945, George E. Ives took over the grist-milling operation, and George's son Everett then operated the mill from 1951 until his death in 1961. Everett's son-in-law and partner, Charles Roberts, continued milling (primarily animal feed) until he retired in 1985, and then the mill closed. A cabinetmaker, John Tobin, purchased the building in 1990, but it now lies dormant, a lone and poignant reminder of the Ives family's illustrious milling history. Everett Ives also operated the sawmill from 1932 until it closed for good in 1962. It was demolished in 1977.

Charles Ives had begun experimenting with a water-powered DC dynamo in 1910, and by 1931 he and his brother George had founded the North Tryon Electric Company. After considerable expansion, it was sold to the Maritime Electric Company in 1943 and then shut down in 1947. The building is now a potato warehouse.

IVES GRIST MILL (FOREGROUND), NORTH TRYON. (LS)

A Light in the Field

Pinette Mill, Belfast

The lumber mill near Belfast, just down the hill from St. John's Presbyterian Church, has a long and colourful history. The original mill was built on the site of the present mill by Lord Selkirk in 1804, at a time when the establishment of a lumber mill played a crucial role in the development, and indeed the survival, of the Island's pioneer settlements. A grist mill was added about 1816, and soon after, shingle and carding mills were in operation at the site under power provided by the Pinette River.

In its early days, the mill was leased to tenants, one of the first of whom, Robert Jones, designed and built St. John's Presbyterian Church (1824-1826). Jones had the timbers for the church milled here and hauled up the hill to the church site by a team of horses. The hand-split shingles were also made at the mill and were fixed to the church exterior with iron nails made by a local blacksmith.

In 1839, fire destroyed the grist mill. The remaining mill properties were sold by John Douse to Alexander Dixon, a miller from England, whose family operated the lumber mill for many years thereafter. It is still operated successfully by its present owner, John C. MacPherson.

PINETTE MILL INTERIOR. (WB)

PINETTE MILL, BELFAST. (LS)

Mills

Bagnall's Mill, Hunter River

A sawmill and grist mill were established in Hunter River by a family named Patterson in the 1840s. The mills underwent many changes over the years and functioned under several different sources of power. The sawmill flourished immediately, as the shipbuilding boom of the mid-1800s created a great demand for local lumber. A long, low building situated across the river from the existing buildings, the sawmill burned down in 1960. The present facility is comprised of the old grist mill building with a large extension that was built on the back in 1948. Both mills were purchased by Ray Bagnall in 1944, and the complex is now managed by his son, Carl Bagnall. It is presently a building supply house and door and window factory.

BAGNALL'S MILL, HUNTER RIVER. (SS)

A Light in the Field

DRAKE FARM, HAZELBROOK. (SS)

(LS)

CAPE TRYON. (SS)

Mills

71

Bibliography

ADAMSON, ANTHONY, AND MARION MACRAE. *The Ancestral Roof.* Toronto: Irwin, 1963.

ARTHUR, ERIC, AND DUDLEY WITNEY. *The Barn.* Toronto: McClelland and Stewart, 1972.

BARRETT, WYLIE. *North St. Eleanor's, The Lost Settlement.* Privately printed, 1987.

BLANCHARD, J. HENRI. *The Acadians of Prince Edward Island, 1720-1964.* Charlottetown: Privately printed, 1964, 1976.

BUSH, EDWARD F. "The Canadian Lighthouse." *Occasional Papers in Archaeology and History* No. 9. Ottawa: Canadian Historic Sites, 1974.

BRUNSKILL, R.W. *Illustrated Handbook of Vernacular Architecture.* London: Faber, 1971.

CLARK, A.H. *Three Centuries and the Island.* Toronto: University of Toronto Press, 1959.

CUNNINGHAM, ROBERT, AND JOHN B. PRINCE. *Tamped Clay and Saltmarsh Hay.* Fredericton: Brunswick, 1976.

DUPONT, J.-CLAUDE. *Histoire Populaire de L'Acadie.* Montréal: Lémeac, 1978.

ENNALS, PETER. "The Yankee Origins of Bluenose Vernacular Architecture." *American Review of Canadian Studies,* Vol. 12, No. 2 (Summer, 1982).

GALLANT, CÉCILE. *Le Mouvement Coopératif chez les Acadiens de la région Évangeline.* 1982.

GILLIS, BRIAN. *Barns of Prince Edward Island.* Charlottetown: Privately printed, 1975.

GLASSIE, HENRY. *Patterns in the Material Folk Culture of the Eastern United States.* Philadelphia: University of Pennsylvania Press, 1969.

GOWANS, ALAN. "New England Architecture in Nova Scotia." *The Art Quarterly* (Spring, 1962).

HARRIS, CYRIL M. *Historic Architecture Sourcebook.* New York: McGraw Hill, 1977.

HAINSTOCK, BOB. *Barns of Western Canada.* Victoria: Braemar, 1985.

HALSTED, BYRON D. *Barns, Sheds and Outbuildings.* Brattleboro, Vermont: Stephen Greene, 1977.

HOWATT, CORNELIUS. "The Farm Family." *The Canadian Collector,* Prince Edward Island Centenary Issue, Vol. 8 (1973), pp. 21-26.

HUMPHREYS, BARBARA A., AND MEREDITH SYKES. *The Buildings of Canada*. Ottawa: Parks Canada, 1974.

THE ISLAND MAGAZINE.
 BUMSTED, J.M. "The Stewart Family and the Origins of Political Conflict on Prince Edward Island." No. 9 (1981), pp. 12-18.
 GRAHAM, ALAN. "A Light on the Sandhills." No. 9 (1981), pp. 28-30.
 KNOX, GEORGE. "Island Fences." No. 8 (1980), pp. 21-26.
 MACQUARRIE, KATE. "The Tryon Woolen Mills." No. 36 (1994), pp. 9-12.
 MORROW, MARIANNE. "The Builder: Isaac Smith and Early Island Architecture." No. 18 (1985), pp. 17-23.
 STEWART, DEBORAH. "Robert Bruce Stewart and the Land Question." No. 21 (1987), pp. 3-11.

MEACHEM, J.H. *Illustrated Historical Atlas of Prince Edward Island*. Charlottetown: J.H. Meachem, 1880; Centennial Edition, Prince Edward Island 1973 Centennial Commission: Charlottetown, 1973, 1989.

PRIAMO, CAROL. *Mills of Canada*. Toronto: McGraw Hill, 1976.

ROGERS, IRENE L. "Heritage in Building." *The Canadian Collector*, Prince Edward Island Centenary Issue, Vol. 8 (1973), pp. 26-30.

ROSS, DAPHNE. *Seascapes of Prince Edward Island*. Charlottetown: Ragweed, 1992.

SHARPE, ERROL. *A People's History of Prince Edward Island*. Toronto: Steel Rail, 1976.

SLOANE, ERIC. *An Age of Barns*. New York: Ballantine, 1974.

SYMONS, HARRY. *Fences*. Toronto: McGraw Hill-Ryerson, 1958.

TRANSPORT CANADA, CANADIAN COAST GUARD. *Atlantic Coast: List of Lights, Buoys and Fog Signals*. Ottawa: Queen's Printer, 1980.

TYRWHITT, JANICE. *The Mill*. Toronto: McClelland and Stewart, 1976.

WITNEY, DUDLEY. *The Lighthouse*. Toronto: McClelland and Stewart, 1975.

THE AUTHOR wishes to acknowledge references to community histories too numerous to list here and to articles published in the following newspapers: *The Examiner, The Charlottetown Guardian-Patriot, The Islander, The Charlottetown Herald, The Prince Edward Island Register* and *The Journal Pioneer*. The author has specific information on these references, if required, and welcomes correspondence.

Index

A

Abrams Village 37, 53
Acadian Fisherman's Co-op Ltd. 33, 37
Annandale 34, 35, 42

B

Bagnall, Carl 70
Bagnall, Ray 70
Bagnall's mill 70
Balderston, George D. 63
Baldwin Road 52
Barclay, James 67
Barrett, Cecil 45
Basin Head 40
Basin Head Museum 40-41
Bear Reef 29
Beaton, Alexander 30
Belfast 69
Bideford 55
Blockhouse lighthouse xii, 21, 22
Bloomfield 66
Bonshaw 59
Boswell farm 49

Brae xv, 55
Bridgetown Mill 63
Buffalo, New York 58
Butcher, James 21

C

Cairns, John 33
Cape Tryon 71
Caribou, Nova Scotia 28
Charlottetown 20, 21, 43, 59
Clarke, Dennis 61
Clarke, Richard 61
Clinton 19
Coast Guard 18, 19
Coleman 67
Corcoran, Alan 52
Corcoran barn 52
Court, Beecher 39
Court Brothers 39
Court, Quentin 39
Court, William 39
Creamer, Bernard 30

D

Dawson, Richard 68
Dennis, Allison 58
Department of Tourism 62
Desable xiv
Dillon, Paul 58
Dixon, Alexander 69
Douglas, Bill 58
Douse, John 69
Drake farm 50, 71

E

East Point lighthouse 17, 19, 30-32
East Wiltshire 45
Egmont Bay 37
Eldon 42
Elm Wood Farm 44

F

Finlayson, William 20
Flat River 42
Fort Amherst-Port La Joye National
 Historic Park 21
Freetown 44
French River 24, 35
French River Harbour 35

G

Gabriel, Gerry 60
Gallant barns 53
Gallant, Joseph 53
Gillis barns, Miscouche 53
Gillis barns, Lyndale 53
Gillis, Donald 53
Gillis, Roger 53
Gillis, Urban 53
Glenwood 65
Grand Tracadie xiv
Guernsey Cove 47

H

Harris, Harry 31
Hazelbrook 50
Hartsville xiii
Hay barracks 45, 54, 61
Heritage Places Protection Act xv
Hillsborough Bay 20
Holland, Samuel 61
House of Assembly 20
Hunter River 70

I

Indian Head lighthouse 17, 26-27
Indian Point 26
Ives, Charles 68

Ives, Everett 68
Ives, George 68
Ives, George E. 68
Ives mill xv, 68
Ives, Thomas 68

J

Jones, Robert 69

K

Kespemenagek 30
Knutsford 47

L

Lake Verde 45, 54
Leard mill 67
Leard, Peter Warren 67
Leard, Waldron 67
Leard, Warren 67
Long River 65
Lyndale 53

M

MacAusland, Alan 66
MacAusland, Archibald 66

MacAusland, Edward 66
MacAusland, Fred 66
MacAusland, Harry 66
MacAusland, Reginald 66
MacAusland's mill 66
MacCallums Point 26
MacDonald, William 23, 30
MacIntyre, W.S. 30
MacIsaac, Bennie 23
MacLeod farm xiii
MacPherson, John C. 69
Malpeque 35, 56
Maritime Electric Company 68
Maynard, Wilfred 58
Mill River 66
Milligan farm 57-58
Milligan, James Edgar 57, 58
Milligan, Jim 58
Milligan, Robert 57
Milligan, Thomas 57
Milton 50
Miminegash 34, 35
Miscouche 53
Moar, James 52
Montrose 43, 56
Moore barns 54
Moore, John 54
Moore, Wrixon 54
Morrison, George 57, 58
Mount Carmel 42
Mount Hope 51
Munns Road 49

Index

N

Naufrage 34
Naufrage lighthouse xv
New Annan 47
New London Bay 24
New London lighthouse 24
New Perth 44, 52
North Cape 23
North Cape lighthouse 19
North Lake 35, 36
North Milton 51
North Point 19
North River 65
North Rustico 25, 39
North Rustico Harbour 37
North Rustico lighthouse 25
North Tryon xv, 68
North Tryon Electric Company 68
North Wiltshire 63
Northam 57, 58
Northumberland Strait 20, 23, 30, 31, 33, 59

O

O'Leary sawmill 64
Orkney Islands, Scotland 52
Orwell Corner 61-62
Orwell Cove 61
Orwell, Sir Francis 61

P

Panmure Head lighthouse xiv, 19, 29
Panmure Island 29
Panmure Ledge 29
Peters, Captain Charles 26
Pickard, Keith 60
Pickett farm 47
Pineau, George ("Joe Polly") 25
Pinette 47
Pinette lumber mill 69
Pinette River 69
Point Prim lighthouse 17, 20
Potato Barn 45
Prince Edward Island Museum and Heritage Foundation 40, 62

R

Ramsay, Bertram 56
Ramsay, Donald 56
Ramsay farm 56
Ramsay, Fred 56
Richards carriage house 55
Richards, William, Captain 45, 55
Roberts, Charles 68
Robertson barn 49
Robinson, Thomas 20
Rocky Point 21, 22
Rocky Point lighthouse 19, 21-22
Rogers farm xv, 55

Rogers, William Russell 55
Rogers, William Thomas 55
Rustico Harbour 39

S

St. Chrysostome 46
St. John the Baptist Roman Catholic Church 53
St. John's Presbyterian Church 69
Savage Harbour 34
Selkirk 42, 61
Selkirk, Lord 20, 69
Selkirk Settlement 42
Skinners Pond 49
Smith fish cannery 40, 41
Smith, Isaac 20
Souris 30
Souris lighthouse 19
South Melville 46
Stanchel 43
Stewart, David 59
Stewart, George 28
Stewart, Robert Bruce 59, 60
Stewart, Robert Bruce, Jr., 59
Stewart, W.F. Allen 60
Strathgartney 46, 59, 6
Suffolk 71
Summerside 17, 26, 27

T

Taylor, Merrill 21
Taylor, Stanley 21
Tignish 33
Tignish Run 34
Tobin, John 68
Tryon River 68

U

Union of Fishermen of Egmont Bay 37

V

Victoria 49

W

Walsh, Richard 20
Warren Mill 65
West Point lighthouse 23
Westmoreland 54
White Sands 33
Wilkie, Garth 56
Wilmot Valley 45
Wood Islands 28
Wood Islands jetty light 16
Wood Islands lighthouse 17, 19, 28

Index